kinds, or to take another helping, saying eatie, eatie, or drinkie, or just a few English words, and would have been offended if we refused anything. After this wonderful meal was over, with the boy as our guide, we start up the hill at the back of the monastry, to obtain a good view of the surrounding country. We pass through a beechwood, with very fine trees, Here and there the ground is covered with patches of wild mauve crocus, a wild snow drop or two and other flowers are also to be seen. Further along the road gets quite rocky and very steep, but Morrie Guben and I still continue to scramble up, and are quite repaid by a glorious view into the valley, and of the ruggid rocky peaks, and in the distance mountain tip after mountain. We must indeed be at a great hieght. Time does not allow us to go to the final peak. We hurry down again, anxious to be in time to see t

she invites us there that afternoon. We ask
them to come and see us on Tuesday
afternoon, and Doris and Alice come to tea
with us on Sunday. On Sunday we
pay a visit to the church in the Avenue
de la Grande Armée where we used to
go, it is just as full as ever. Of course
we must spend one afternoon in the
Louvre, and as we have just come from
Italy, we are anxious to see chiefly the
Italian pictures there, so Wednesday
afternoon is taken up with that. We first
of all pass through the large halls, and
I pick out some of my favourites there.
"St. Michael & the Dragon" by Raphael,
the beautiful face of the saint.
Raphael's Madonna, Christ and St. John
the Baptist, a very familiar friend.
Leonardo de Vinci's "Annunciation", the
lovely angel in a yellow robe. Two or
three by Montagna, one a "Madonna
& Child", surrounded by saints, the
curious back-ground behind her throne

# A GIFT OF SUNLIGHT

# A GIFT OF SUNLIGHT

The fortune and quest
of the Davies sisters of Llandinam

## TREVOR FISHLOCK

Gomer

Published in 2014 by
Gomer Press, Llandysul, Ceredigion, SA44 4JL

Reprinted 2015

ISBN 978 1 84851 811 7

This book is published with the financial support of the
Welsh Books Council.

Printed and bound in Wales at
Gomer Press, Llandysul, Ceredigion

# Contents

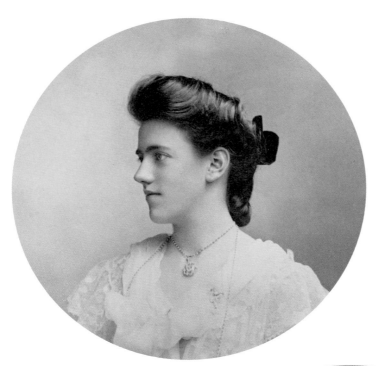

Edwardian style: upswept hair and
summer dresses. Gwendoline, left,
and Margaret keep an appointment
with the photographer

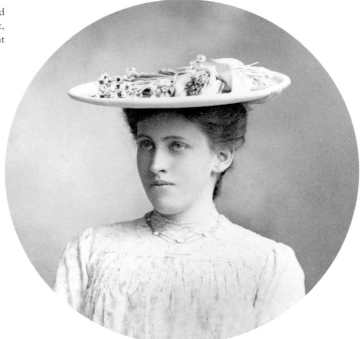

# A suitcase in the attic

herever they travelled, in France, Italy and Germany, and among their native hills in Wales, Gwendoline and Margaret Davies gathered flowers. They pressed them in their notebooks in remembrance of places and events. A bloom picked near the tranquil hilltop city of Assisi in 1909 survives as an evocative souvenir, the faded leaves and petals as fragile as a butterfly's wing. Seeing it we can picture the sisters in their Edwardian straw hats and long dresses, absorbed in their woodland search on an afternoon in spring.

I found the flower in a miscellany of correspondence, newspaper cuttings, photographs and keepsakes stored in a suitcase. The case is of ivory leather, lined with peach-coloured silk, and bears the initials GED: Gwendoline Elizabeth Davies. Standing by the desk in my attic, during my writing of the Davies sisters' story, it was a source, a companion, a spur and a talisman, its brimming contents a lucky-dip chronicle of their lives. In an early photograph they are tots balanced on ancestral knees at a gathering of their grandfather's family. Other pictures record changing fashions in hairstyles, hats and hemlines from Victorian years through the emergence of the ankle and into the 1950s.

Before the first world war they were old hands on the Channel ferries and Continental trains; pioneer motor car tourists, too. Passports record Gwendoline's height as five foot two, and her younger sister as an inch taller; and both had blue eyes. Among the memorabilia a letter from

the king of the Belgians thanks them for helping refugees in 1914. A medal salutes their Red Cross service in France in 'The Great War for Civilization.' A note pencilled by their brother David describes life and courage in the trenches of the western front. Words written by their cousins at Gallipoli still pierce the heart. A French ration card shows the sisters' bread allowance in 1918 as 100 grams a day. A British ration booklet of 1918, valid for meat and butter, urges 'Grow potatoes if you can. The nation cannot have too many.' A wad of French banknotes bulges an envelope, and French coins rattle in another.

Gwendoline and Margaret believed that beauty had a power to do good. In the depression years of the 1920s and 1930s they transformed their home in Montgomeryshire into a place of music, song, poetry, paintings, printing, festivals and flowers among glorious trees. Edward Elgar came; and Ralph Vaughan Williams and Gustav Holst. Henry Walford Davies was a stalwart. So, too, was Adrian Boult. 'Such a dear,' said Gwendoline. George Bernard Shaw visited three of the sisters' festivals. In the suitcase I found a piquant postcard he wrote to Gwendoline concerning the colour of his beard. Numerous conferences on economics, education and peace made their home a parliament of sorts.

In that letter-writing age ink was the sisters' element. Gwendoline tutted at anything typed. The letters in the suitcase medley helped me to understand some of the enigmas of their remarkable lives. I was in my twenties when I first saw their collection of paintings and sculpture at Cardiff; and I remember the thrill of revelation and discovery. At first I found the sisters elusive: in descriptions of their characters words like silent, tongue-tied and self-effacing stuck to them like burrs. Reticent they certainly were, but as collectors of paintings they raised a beacon and followed their hearts. Their achievement was a collection of stunning Impressionist work of international standing, pictures of their own choosing, art they loved, far ahead of its time in Britain.

Their grandfather found his fortune deep in the buried sunlight of Rhondda coal. His grandchildren never forgot the origins of this wealth. They, too, steered by the old man's Calvinistic compass and directed their

philanthropy towards their country's education, culture and rebirth. The sisters' purpose was to share with the public the inspirational energy of paintings and music. Three centuries earlier the Welsh antiquarian Robert Vaughan said that his great national book collection sprang from 'a love of my country and our ancestors'. The same spirit moved Gwendoline and Margaret. Their assembly of brilliant paintings is a marvel. For love of their country they gave it to the people, a gift of sunlight.

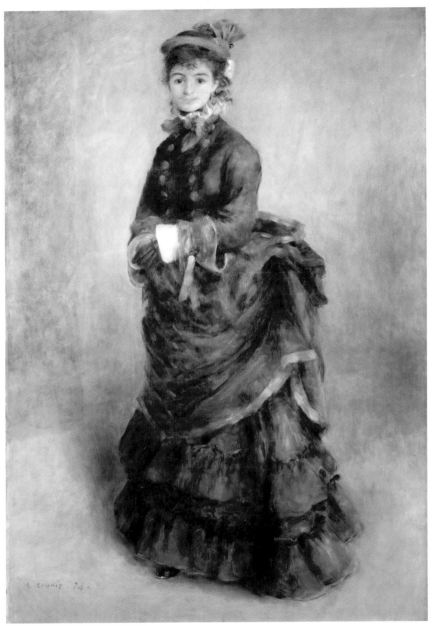

Pierre-Auguste Renoir 1841–1919                    *La Parisienne* 1874

Her pervading modernity; her independent air; simple, beautiful and fresh; la dame en bleu;
The Blue Lady; a blue of purity; blue upon blue; a heavenly blue

# Paris, Wales, blue belle and California bear

n 1874, through the weeks of winter and into the spring, Pierre-Auguste Renoir worked towards a deadline. At his studio in the rue Saint-Georges in Montmartre he had several paintings on the go. An exhibition was opening in Paris in mid-April and he was anxious to sell work to pay his rent. He turned thirty-three on 25 February, a slim man with a short beard and slightly ragged moustache, a flop of hair over his brow. He was in the flood of his talent.

In the largest of the six paintings intended for the exhibition Renoir conjured a slender girl in a silk costume. Her white cuff flashes against its deep and remarkable blue. Her jacket boasts a dashing double parade of buttons and her skirt is drawn into the fashionable bustle of the time. A blue hat sits jaunty on her curls. A blue bow closes her collar. She tugs gently at her gloves. Nothing in the painting's hazy background distracts our eye. We see simply the girl herself. She feels pretty. She turns towards us, her dark brown eyes attentive. She pauses, poised, as the painter lassoes the light and steals an instant of her life.

Renoir finished the painting and varnished the canvas so that it was ready to go on show. After a while he reconsidered and decided it was not quite complete. He combined his passion for painting women with a mastery of fashion's architecture. His upbringing had schooled his eye for fit and finish and feminine detail. Because his father was a tailor and his mother a dressmaker, Renoir knew his way around the garnishes of style,

the hats and gloves, buttons and beads, lace and velvet, flounces and fur. As an artist he delighted in the sheen of a ribbon and the shimmer of silk.

In final punctuation he gave the girl's brown hair an extra curl or two and awarded her a dainty earring. Now the masterpiece really was complete, a sensual picture of timeless charm. It would earn its place in the story of art. Meanwhile, as was his habit, Renoir cleaned his brushes and strolled to the Café de la Nouvelle Athènes to join the gossip of his artist friends.

Around that time, shareholders of the Ocean Coal Company in Wales gathered to mark their esteem for David Davies, their chairman and the creator of their wealth. The very model of a Victorian self-made man he was a phenomenon. At fifty-five and in his formidable prime, he was a coal baron at the top of the British energy industry. His annual share of the company's profits was £95,000.

The shareholders presented him with a portrait of himself painted by Ford Madox Brown. The commission was awarded on the recommendation of George Rae, David Davies's banker. Rae had been Madox Brown's patron since 1861 and knew his masterpiece, titled *Work*, first exhibited publicly in 1865. This was a radical hymn to an ideal of the dignity of labour and depicted navvies as heroes of toil, laying pipes in Hampstead. Work was a subject close to Davies's heart.

The fee for the portrait and a companion painting of his wife, Margaret, was £500. Madox Brown welcomed the commission. Like Renoir he knew what it was like to be an artist short of money. He once borrowed to pay for the funeral of one of his children. Meanwhile, he suffered as he painted, switching his brush from right hand to left to relieve the torment of gout.

Davies sat for the portrait in October and November 1873 at his mansion by the River Severn in Montgomeryshire. He settled into an armchair of red leather, his hat in his right hand, a gold watch chain

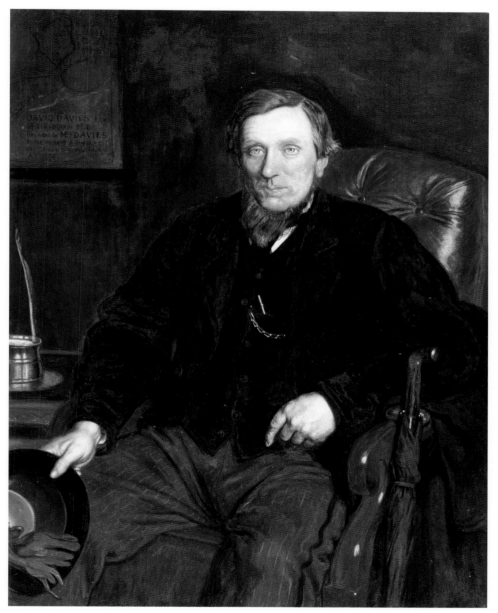

Ford Madox Brown 1821–1893                                    *David Davies* 1874

Madox Brown sees a gleam in the Top Sawyer's eye, the shrewdness and determination in a Victorian hero of Wales

curving across his waistcoat. In that whiskered age of dundrearies, mutton chops and Gladstonian trenchers he shaved his cheeks, chin and upper lip so that his beard flowed as a cravat from his jaw to the top of his shirt. To waggish minds the style suggested a noose and was larkily dubbed a 'Tyburn collar'. Madox Brown delineated David Davies's square face and firm jaw, the characteristic thin-lipped set of the mouth, the arresting and inspectorial blue-eyed gaze.

David Davies was not the sort to sit in silence. As a ready talker he could easily give a lecture of two hours and more. He would remind a listening crowd that in his career he had done a great deal. He had started work as a boy and talked proudly of his journey from hardscrabble to household name. 'I've never owned a sixpence,' he liked to say, 'that I hadn't earned by my own hand.' Madox Brown enjoyed his company. 'I like old Davies,' he wrote to his daughter, 'he is as rough as a California Bear but so kind-hearted – and really a man of genius – most interesting to talk to.'

He completed the portraits at his studio in London early in 1874. Delayed by gout he presented them to Mrs Davies on 12 February.

Paris was in a time of renewal and hope. Three years had passed since the horrors and humiliations of the Franco-Prussian war. In July 1870 Emperor Napoleon III sent his forces against Bismarck's Prussia. Renoir served in the army as did his friends Edouard Manet and Edgar Degas. They mourned the death in action of their talented fellow artist Jean-Frederic Bazille. At the battle of Sedan in September the Prussians fought the French army to its knees and captured the emperor himself. Renoir was discharged from the cavalry, seriously ill with dysentery.

The Prussian army besieged Paris during the harshest winter in memory. Parisians sent letters to their friends and families by the first air mail, the calico gas balloons piloted by bold aeronauts who flew over the encircling Prussian forces. Gunners bombarded the city for four months until the

hungry people surrendered. Seeking peace, France paid an indemnity of five billion francs and lost the provinces of Alsace and Lorraine. In the wake of the Prussians' withdrawal the working-class radicals of the Paris Commune seized the capital and imposed their insurrectionary rule in ten weeks of terror, from March to May 1871. The government decisively and brutally broke the Commune and restored order. Twenty-five thousand people perished in the slaughter of the 'semaine sanglante'. Manet drew scenes of the fighting and of the bodies in the streets. In the confusion Renoir narrowly escaped the busy firing squads.

Paris repaired its wounds and began to recover its former status as culture capital of the world. During seventeen years as the autocratic Prefect of the Seine, 1853-70, Baron Georges Haussmann had transformed the city by ruthlessly levelling teeming medieval districts, evicting inhabitants and building on a majestic scale. In this epoch of convulsion Haussmann created on the banks of the defining Seine an exhilarating geometry of imperial squares and grand tree-lined avenues. Haughty and handsome limestone facades rose in harmony with extensive gardens. Cafes sprang into life on broad pavements. New river bridges gave unity and access, and quays created space. Street lighting, clean drinking water and sewers were modern blessings. Four new stations, Gare du Nord, Gare de l'Est, Gare de Lyon and Gare Saint-Lazare, asserted modernity and the glorious sovereignty of railways. New lines reached out to the suburbs and rural hinterland.

Paris swaggered again as the stylish place to be. Hundreds of artists from France, Italy and elsewhere in Europe migrated to its numerous schools and studios. The city was in flux. Renoir worked in a brotherhood of innovative painters exploring the frontiers of technique and atmosphere, reacting against the Romantic tradition. Others were Manet, Degas, Claude Monet, Camille Pissarro, Alfred Sisley and Paul Cézanne. None of their families had painting in the blood. The only woman in their early circle was Berthe Morisot, a painter who also modelled for Manet. She shared with the majority of them a comfortable middle-class background: her father, like Manet's, was a senior civil servant. Only Renoir and

Claude Monet 1840-1926                    *The Palazzo Dario* 1908

Waterlight: one of the paintings Monet began on his first Venetian journey at the age of sixty-eight

Pissarro had humble origins. The American Mary Cassatt joined the group in 1877, and her presence, with Morisot's, helped to define the movement as open to women and decidedly progressive.

The modernist painters worked in a hurry to capture the moment, to transmit a sensation of movement, to make paint itself seem to quiver. Inspiring voices urged them to embrace the here and now, the reality before their eyes. In 1863 Charles Baudelaire, the poet, sensualist and art critic, called on them to defy the heavy hand of official art and depict 'the heroism of modern life'. The poet Stéphane Mallarmé insisted on a democratic art for a democratic age. The painter's eye, he said, should 'learn anew – seeing only that which it looks upon, and that as for the first time'. The artists made no attempt to disguise brush strokes and painted with lizard-tongue flickers rather than classical strokes. They sought the rhythms, realities and sensations of life in boulevards and gardens, restaurants and the racecourse. They painted men, women and children easy in the sun, unbuttoned by the river, lazy at the picnic, dancing in the park, sparkling in the theatre, skittering over cobbles made mirrors by the rain, in transit and on the hop. In studies of domestic intimacy the artists' friends sat and stood in modern attitudes, informal and relaxed. John Rand's invention of the soft metal paint tube in 1841 enabled painters to carry their colours with them as they worked in the open air. Along the Seine, in Asnières, Gennevilliers and Argenteuil, they painted villages, flowers, boats and water's coruscations. On the Channel coast they had waves and cliffs and the parasols and pantaloons of la plage: the beauty of the ordinary. Edmond Renoir said his brother Pierre-Auguste depicted 'a faithful picture of modern life. What he painted, we see every day'.

Artists had also to compete with the advance and threat of photography, and the ingenuity and artistry of the photographer. In their favour the artists had their techniques of paint-handling, as well as the texture, thickness and colour of paint itself. They responded to the customer's appetite for brilliant and detailed painting, for 'proper pictures'. They also profited from the demand for high-quality engraving in a rapidly-growing press.

The butterfly ball of fashion, meanwhile, was for many painters a delight unending. 'The latest fashion,' Manet pronounced, 'is absolutely necessary for painting.' Women blossomed in their spring and summer dresses, framed by men in coal-dark coats. Tailors, couturiers, and milliners prospered. Le Bon Marché and Le Louvre were boulevard palaces selling stylish and affordable ready-to-wear; and, with modern water closets, were positively liberating.

Such style magazines as Le Moniteur de la Mode and La Mode de Paris published fashion plate illustrations of the latest cut and colour and the accoutrements of style. In La Mode et la Parisienne, Emmeline

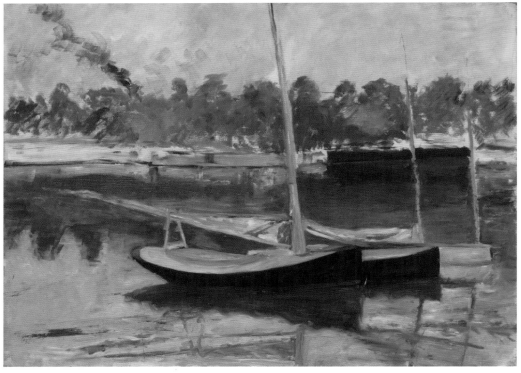

Edouard Manet 1832-1883      *Argenteuil, Boat (study)* 1874
Manet's eye for reality: romantic reflections of boats and the nose-wrinkling smudge of smoke

Raymond had already boasted: 'Sans doute les Parisiennes sont femmes, mais elles sont plus femmes que toutes les autres femmes.' Renoir gave the title *La Parisienne* to his painting of the girl in blue because she was one of a recognizable and new type, the young women about town, unaccompanied but also modest, strolling the boulevards in fashionable dresses, the sort of ordinary girls he knew well.

His model for *La Parisienne* was Marie-Henriette-Alphonsine Grossin, a milliner's daughter who became a vaudeville actress and took the stage name of Henriette Henriot. Sixteen years old when she posed for him, she was his favourite model for some years and he painted her at least eleven times. In *La Parisienne*, as in other works, he enhanced her looks.

Her blue dress derived its striking colour from the dyes of the time. Perhaps it was one of those created by William Perkin, a boy-wonder of a chemist. He was only eighteen when he experimented with coal in his shabby stink of a workshop in London's East End. Perkin set out in the hope of making artificial quinine to defeat malaria. The outcome was unexpected. When he reduced the coal to its essential coal-tar he was left with a light purple dye. It kept its brilliance and did not fade. And for its colour he invented the word mauve. His discovery ended the textile industry's dependence on dyes derived laboriously from plants and minerals. His artificial reds, greens and blues transformed the colour possibilities in clothing manufacture and made him magnificently rich.

In Paris a number of artists in their mid-thirties coalesced as a tectonic plate rubbing against art's entrenched disciplines. Art schools taught conservative brushwork and the contemplation and copying of the old masters. Art patrons were accustomed to a formula of pictures well-executed and easy to understand, formal portraits of gentlemen and pretty women, patriotic or military themes immaculately detailed and finished. Academic convention called for narrative artists to locate their paintings in classical literature and theology, to enshrine human figures as gods and

goddesses in legendary adventures and the Italian Renaissance. If nude they often wore the acceptable fig leaf of mythology.

The modern-minded challenged doctrine and tradition. To the art establishment, however, many of the new paintings looked sketchy, smudgy, garish, informal, unfinished, not at all like the 'real art' they saw in the galleries. Picturesque paintings of the lower classes on the land and in the streets were untraditional and unwelcome. In the 1870s, in the aftermath of war and insurrection, some of the arbiters of taste nervously detected anarchy in the new trends.

To advance in their profession young artists submitted work to the jury of the annual Paris Salon, the state-run exhibition which displayed hundreds of pictures and attracted great crowds. The selection jury, however, was hidebound and riddled with intrigue, a barrier to ideas, a fence at which new work fell. For artists, then, the public's access to art via exhibitions was a question of survival. Renoir and others saw that if they were to have recognition and a market they must arrange their own show free of juries and the intervention of officialdom. In 1873 they started a cooperative, the Anonymous Society of Painters, Sculptors and Engravers, and met in Renoir's apartment. They had no particular leader. Their purpose was egalitarian. Manet, although a fearless founder of modern art, unconventional and rebellious, did not join them. In his *Déjeuner sur l'herbe*, 1863, a naked young woman picnics with two fully-dressed men. His challenging nude *Olympia*, exhibited at the Salon in 1865, has the cool and indifferent gaze of a courtesan. Both of these pictures had impeccably classical sixteenth-century sources; but in the 1860s both were scandalous affronts. Manet, however, had no wish to burn his bridges to the Salon. Although he did not take part in the Anonymous Society's show his genius ensured that he remained the group's influential figure, a leader in the advance of modern painting.

The Anonymous Society rented a capacious photographic studio in the busy boulevard des Capucines. More than thirty artists submitted 165 pictures and the exhibition opened on 15 April 1874 for a month with a charge of one franc for admission. Some of the painters were professionals,

old hands who showed at the Salon; some were weekend amateurs. Renoir himself arranged the paintings, hanging them sympathetically so that each one could be viewed easily, in contrast to the crammed floor-to-ceiling muddle of pictures at the Salon.

In some accounts the exhibition was a showdown, the gallant avant-garde pitted against the stiff judges of the Salon. But a number of critics in the Paris press agreed that they liked what they saw. 'Lively, brisk, light, captivating,' was one verdict. 'A new road, the pioneers of the painting of the future,' was another. Most critics sympathized with the artists' reaction to the Salon; and one of them drew attention to their skill, delicacy and colour sense. A few called the artists revolutionaries and intransigents, meaning anarchists, and one derided the pictures as 'palette scrapings laid on dirty canvas'. Similarly, The Times looked at an exhibition of contemporary French art in London and detected 'evidence of as wild a spirit of anarchy in French painting as in French politics'.

Most famously the exhibition itself led to the coining of the term Impressionist. Monet showed an unfinished Turner-like painting the Salon had rejected, a simple swiftly-painted view of the misty harbour at Le Havre. Pressed to give it a title on the spur of the moment he called it *Impression:Sunrise*. A couple of reviewers took up the word and used it in their mockery of the artists and their way of painting. The critic Jules Castagnary, however, saw intelligence and a captivating liveliness in the painters and their new style. 'If one wants to characterize them with a single word one would have to create the new term of Impressionist. They are Impressionist in the sense that they render not a landscape, but the sensation produced by a landscape.'

Journalists seized gratefully on the shorthand label of Impressionist. Some commandeered it as a term of scorn. A critic in Le Figaro referred playfully to Berthe Morisot. 'There is also a woman in the group,' he wrote, 'as in all notorious gangs.' The artists, however, adopted Impressionist as their badge of honour. Their movement could have arisen only in the creative ferment of Paris; and now it had an unforgettable name.

One of the first reviewers to see *La Parisienne* thought the girl a poppet. 'This little lady,' he mused, 'is trying hard to look chaste.' He liked the 'daringly coquettish' tilt of her hat and the 'little black mouse' of the shoe peeping beneath the flounced skirt. He was lyrical about the 'heavenly blue' of her outfit and humorously chided Renoir for painting a dress that did not reveal enough. 'Nothing,' he harrumphed gently, 'is more annoying than locked doors.' Renoir's next painting of Henriette Henriot, c.1876, was rather more revealing.

The Impressionist exhibition was not a commercial success. The artists made little profit. Most would have to wait for fame and riches. There would be seven more of their exhibitions, the last in 1886. Pissarro was the only one who showed at all eight. Renoir sold his sumptuous portrait *The Theatre Box* to a dealer for 425 francs: not much, but he had to make a living. Later in the year Henri Rouart, a minor painter who had exhibited at the show, bought *La Parisienne* from Renoir for 1,500 francs. An Impressionist supporter, lifelong friend of Degas and a prosperous refrigeration engineer, Rouart sponsored another Impressionist exhibition in 1882.

His famous private collection in Paris was a port of call for many art patrons, and included works by Jean-Baptiste Camille Corot, Jean-François Millet, Degas, Manet, Monet, Cézanne, Pissarro and Renoir. The art historian Armand Dayot, who looked closely at *La Parisienne* at Rouart's home in 1891, said: 'The woman in blue is one of the artist's major works. M. Renoir is hardly concerned with the worldly elegance of draperies, and the less coquettish country girls of Watteau and Lancret would smile pityingly at the woman in blue's untidy flounces, but this is admirably offset by the imperishable virtues of the picture; time can only improve the exquisite quality. What charming things one could write about this superb portrait, about this figure with her pervading modernity, who glows with a cheerful vitality and who emerges from that pile of ridiculous clothing like a rare flower from a deliberately crumpled paper cornet.'

The artist Paul Signac studied the painting in Rouart's collection in 1898. The purity and intensity of the blue dress enchanted him. 'One would think,' he wrote happily, 'that this picture painted twenty years

ago had only left the studio today. The tricks of colour are admirably recorded. It is simple, it is beautiful and it is fresh.'

Renoir's *La Parisienne* and Madox Brown's portrait of David Davies, paintings of 1874, are two aspects of the same story. Davies channelled his colliery profits into charity, chapels and the founding of education as well as the purchase of land. Madox Brown's painting salutes his business achievement. Early in the twentieth century Davies's grandchildren, David, Gwendoline and Margaret inherited his immense fortune. From their twenties the sisters accumulated the collection of French paintings that in its time was the best in Britain.

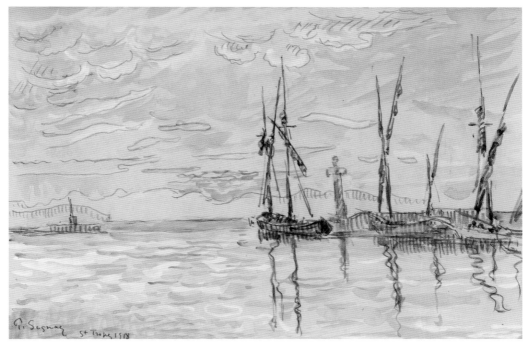

Paul Signac 1863–1935                                                                 *St Tropez* 1918

Self-taught, Signac lived his early life in Montmartre. Georges Seurat and Pissarro influenced his work. Gwendoline bought this brilliant watercolour in 1920

During the early years of their collecting, Henri Rouart died in Paris and his pictures were sold. *La Parisienne* appeared for sale at the Grosvenor Gallery in London in 1913 and Gwendoline Davies bought it for £5,000. She doubtless felt the same warmth for the picture expressed by Armand Dayot and Paul Signac in the 1890s. She loved it instantly, its charm and simplicity, so we can imagine her elation. Half a century later The Times reminded its readers that when she bought the painting such art was controversial in Britain, that it 'took courage to buy even the most enchanting Renoir. The great picture is *La Parisienne*, Renoir in the grand manner'.

The girl in blue is the frontispiece of the collection Gwendoline and Margaret Davies gave to Wales and its national museum. They built the Impressionist and post-Impressionist heart of it over a dozen years when opportunities were ripe and their dedication and collecting desire were strong. Their bequests put Wales and its museum on the world map of art. Madox Brown's portrait of David Davies is displayed close to the sisters' collection, as if keeping an eye on it. This is appropriate: the origins of their saga lie in the epic of their grandfather.

# Moving the mountains

avid Davies was the first of the ten children of David and Elizabeth Davies, Welsh-speaking tenant farmers. The exact date of his birth is uncertain but there is a record of his baptism on 20 November 1818. The Davieses rented a smallholding on a steep hillside above Llandinam village in the Severn valley, eight miles west of Newtown. The name of their patch was Draintewion, meaning a place of thick brambles. They lived in a thatched longhouse divided into two parts, one for the family, the other for their cows and pigs.

Llandinam, a name recorded in the thirteenth century, means a church by a small fort. The fertile valley of the Severn was part of the Welsh kingdom of Powys which flourished from the fifth century to the twelfth. In 1075 the Norman colonist Roger de Montgomery fortified a hilltop ten miles east of Llandinam and called it Montgomery after his home in Calvados. He ruled as a lord of the March, the frontier land from Chester to Chepstow designated by William the Conqueror as a buffer between England and unruly Wales. Marcher lords were kinglets in their realms and ruled by right of conquest. Some of their descendants grew troublesome and were, in any case, anomalous, so much so that in 1536 Henry VIII abolished them. He also abolished the March. In its place he created in Wales the new shires of Pembroke, Glamorgan, Monmouth, Brecon, Radnor, Denbigh and Montgomery.

Montgomeryshire's hilly landscape is benign rather than rugged. The mellifluous Welsh words mwynder Maldwyn describe its charm: mwynder means gentle and Maldwyn is the Welsh name for the county. Many farms and houses enfold in their names the noun derwen or its plural derw, meaning oak. Local timber made church belfries and frames for the picturesque black and white houses of the borderland.

Like most country children David Davies helped with harvesting, haymaking and acorn-gathering. He may have attended a class in the village but whatever his schooling it was meagre. At twelve he worked full time with his father. He never forgot the sour brown bread of his breakfasts, a taste that made him weep. As he ate, his mother recited Bible verses. His family were Calvinistic Methodists, the strongest Nonconformist group in Wales, others being Baptists, Congregationalists and Wesleyan Methodists. In the mid-eighteenth century hundreds of teachers walked from farm to farm and taught more than half the population of Wales to read the Welsh Bible. Calvinistic Methodists evolved within the Anglican church and broke from their parent in 1811, creating a distinct body and ordaining their own ministers. The only Nonconformist church of Welsh origin it became a significant social and political influence in nineteenth-century Wales.

Its adherents followed the moral discipline of the sixteenth-century French Protestant reformer John Calvin. They were strictly sabbatarian and teetotal. David Davies never worked on a Sunday. In his later life he relieved his servants 'of any form of unnecessary work on Sundays'. As an employer he called his farmhands to daily prayers and discussed questions of perseverance, redemption and the fight against Satan. He learned as a boy to avoid excessive sleep, to shun idleness, wandering, usury and games of chance. Calvinism suppressed the traditional merriment of fairs, folk music and maypole dancing and discouraged quoits and football. It emphasized education and charity, self-expression and cultural fulfilment in singing and debate. Lay participation and elected leadership encouraged a democratic idea.

Such a demanding faith formed a keel in tumultuous times. At thirteen

David Davies probably heard of the workers' rising of 1831 in Merthyr Tydfil, fifty-five miles to the south, where soldiers killed twenty-five people. In 1839 Chartists campaigning for the vote clashed with cutlass-wielding militia in Llanidloes, five miles from his home. That year, too, Chartists in their thousands marched on Newport in Monmouthshire and troops shot twenty of them. In 1839 and 1843 rioters in west Wales rebelled against rents, tolls, tithes and bullying magistrates. They smashed the despised toll gates, symbols of gentry misrule.

The Anglican church shrank before the Nonconformist advance, its clergy too few to serve the Welsh-speaking majority. An English opinion held that the cause of unrest in Wales was the people's alienation from the Anglican church and a lack of English. Better, said an MP, to send schoolmasters to Wales, not soldiers.

A government commission of 1847 exposed the dismal state of education in Wales and scolded the gentry and Anglican clergy for failing to support schools. The three young English lawyers who formed the commission cross-examined witnesses, mostly clergymen, who blamed chapels for undermining moral progress. The commission's report sensationally tarred chapels and women with the brush of sexual immorality. English critics relished the comment that 'want of chastity is the giant sin of Wales' and derided the 'animal habits' west of the border. The report appeared to many in Wales as contempt for a nation. Like all commissioned reports of the time its pages were bound in blue covers and its critics satirized it as 'the treason of the blue books', the 'traitors' being the Welsh foes of Nonconformity.

In time the report's exposé of bad schooling led to anglicization in education and an acceptance that children should learn English. It also aroused national consciousness and political radicalism. The blue books' indictment revealed a boneless and backward Wales. Few spoke eloquently for it. It was a country lacking a university, a capital, wealth and the creative art of the European Renaissance. From the 1850s, however, it grew an educational and political structure, a university movement gathered strength and education advanced. A rousing song became the national anthem. The eisteddfod celebrations of poetry and music grew

in influence. Writing and publishing prospered in two languages and invigorated journalism, literature and political argument.

⋙⋘

At seventeen David Davies earned his living as a sawyer. He calculated at a glance the quality and quantity of a tree's timber. Men and horses hauled trunks of two or three tons to saw-pits which were typically twelve feet long and six feet deep with planked sides. They rolled and levered the timber onto beams across the pit. David Davies learnt the power of leverage. 'Find a rest for a lever,' he would say, 'and you could lift the world.'

With the tree in place the sawyers cut it with a saw six feet long. One stood in command atop the trunk, the other was in the pit below, showered by sawdust. David Davies invariably took the upper position and delighted all his life in his nickname: Top Sawyer. Indefatigable, he worked by moonlight to finish a job and said he only made mistakes when he took advice. He confidently pledged a remarkable five pounds for a chapel repair fund and astonished those who thought, or hoped, he had overreached himself: he gave ten pounds, not five. For the rest of his life he donated money for chapel-building and repair.

In 1841 the Davieses moved down the hill from Draintewion to a larger farm, Neuaddfach. At twenty-two Davies earned enough to rent some riverside land. The embankments he raised to defend it against the Severn's eroding swirls impressed Thomas Penson, a county surveyor who hired him to lay foundations for an iron bridge across the river at Llandinam. The job was done in 1846 and the bridge still serves. Penson became Davies's mentor and commissioned more work.

It was a year of business promise, also a sad one. Tuberculosis killed David Davies's father and, two months later, his brother Edward. Before long the disease took his brothers John and Richard. Davies was twenty-seven when he signed his father's death certificate; and the only signature he could make was a cross.

By 1851 he was rising stock with a reputation for completing contracts on time and to budget. In May that year he married Margaret Jones of Llanfair Caereinion, twenty miles from his home. He met her there while constructing a bridge. He was thirty-two. She was thirty-seven, intelligent and determined. No doubt she helped him to literacy. He wrote a proper signature on his marriage certificate and developed flowing and unpunctuated handwriting. Margaret gave birth to Edward, the couple's only child, in June 1852.

In 1855 the Top Sawyer launched himself into financial adventure as a railway builder. The wild spending of the British rail mania of the 1840s and the financial crash of 1845 had taught their lessons; and David Davies was in any case more calculating than most. In the mid-fifties Isambard Kingdom Brunel was extending his Great Western line from Gloucester to Neyland in Pembrokeshire to link London with the Irish ferry. Robert Stephenson had already built the Britannia bridge over the Menai Strait to carry London trains from Chester to Holyhead, the port for Dublin. David Davies prospered by building a railway linking Denbigh to Stephenson's north Wales line. He constructed seven railways in all, more than 140 miles of track.

His celebrated feat was to drive a railway through the Cambrian mountains to the west coast. The poor roads to Aberystwyth, Barmouth, Aberdovey and their sisters were served by the last of the stagecoaches. Coastal sailing vessels were the only efficient and affordable transport for coal, fertilizer, furniture and chapel organs.

The route to Aberystwyth was blocked by Talerddig hill, thirteen miles from Newtown, a wall of high rocks, ravines and a seemingly unconquerable bog. According to the Shrewsbury Chronicle, David Davies never allowed the word 'cannot' to enter his vocabulary. He and his engineer Benjamin Piercy drove a cutting of 400 yards through Talerddig and built stations with the stone they quarried. Davies recruited 200 Montgomeryshire navvies and chose for his foremen replicas of his younger self, tough and capable men not yet twenty-five. Such work was for him a pleasure. He relished his role of hands-on boss, rising before dawn

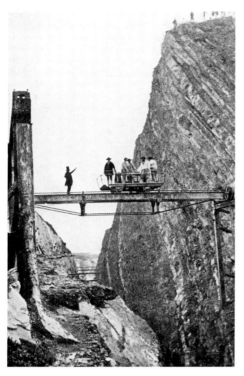

The conductor and his band: David Davies and his
men challenge the ramparts of Talerddig

*(Western Mail)*

to lead the way, wrestling with his men in the work breaks and sharing their bread and cheese. His army laid siege to Talerddig with picks, shovels and gunpowder. A photograph shows him in silhouette, crowned by a Brunelian stovepipe hat, directing the assault. It took two years to drain the bog, reverse the flow of a river and excavate rock to create what was then, at 115 feet, the world's deepest rail cutting. Remarkably, no one was killed.

True to his promise David Davies completed the line on 1 May 1862 and opened the way to the coast. A newspaper styled him 'the eminent contractor'. He arrived for a celebration dinner at the Aleppo Merchant inn at Carno with a bag of sovereigns to pay his men's bonuses. He warned them that the money should not be spent on drink and continued this sermon with the reminder that masters were masters and men were men. 'I deem it the duty of employers to take the highest interest in the well-being of the workmen; and, on the other hand, it is the duty of the employed to sympathize in the efforts of their employers, and when things are so all will go well.'

❧

All went very well for David Davies. 'I found it a very hard thing to save my first hundred pounds,' he once said. 'But I can still use a pick and shovel if need be. I always say the greatest honour a man can enjoy is to

be able to wear a navvy's shirt … and command a thousand pounds.' He hauled himself upward and became a landowner of substance. In 1862, after seven years of building railways, he spent £20,000 to acquire seven farms in and around the Severn valley. The once bright and brawny boy who spoke the 'thee and thou' Montgomeryshire vernacular now owned land that others farmed.

Much of Wales admired this local hero. Most of the kings of the industrial revolution, the ironmasters and copper smelters, had come from England to prosper in Wales. David Davies was a home-grown star of business, a practical man, a gentleman with acres, a squire who walked his land for his leisure, out after the elusive woodcock with his shotgun and his setters and his spaniel. He followed foxhounds on foot, invited a pack to hunt around Llandinam for two weeks every year and paid a pound for every fox killed. As a proper squire he gave the elderly poor of the parish an annual gift of fifteen tons of coal, later increased to twenty; and he hosted an annual party for the village children. He became a chapel deacon and magistrate and accrued a collection of the ceremonial silver trowels he used to lay the foundation stones of new chapels. If he ever needed to remind himself that he had gone up in the world, he had only to leaf through the directories to find his name; and there it was, in the Gentry and Clergy section.

He had no desire to leave his native landscape. On a hillside at Llandinam he built Broneirion, an Italianate mansion, solid rather than elegant, instructing the architect that his valley view should encompass his chapel, the village railway station he had built, and Draintewion, his embrambled birthplace. To embellish the new house he commissioned a frieze, inscribed with his initials and the date: DD 1864, incorporating a sailing ship, a railway locomotive, five cherubs and a girl resting her hand on a shield. He planted the grounds with a status symbol fashionable among wealthy Victorians, the soaring California sequoia, known as Wellingtonia, simply the tallest trees in the world.

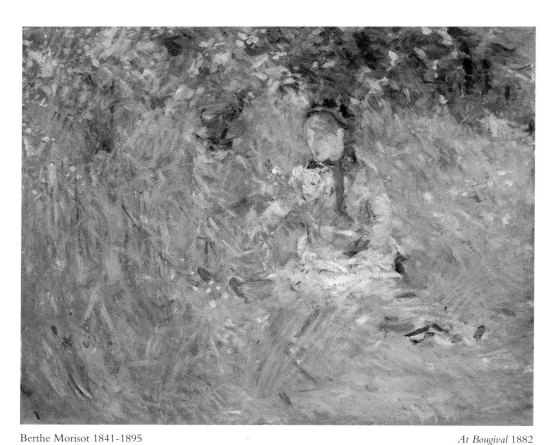

Berthe Morisot 1841–1895                                        *At Bougival* 1882

A pupil of Corot, Morisot showed work at all but one of the eight Impressionist exhibitions. She often painted the tangled garden of her family's home at Bougival, near Paris. In this picture her daughter Julie presents a flower to her nanny

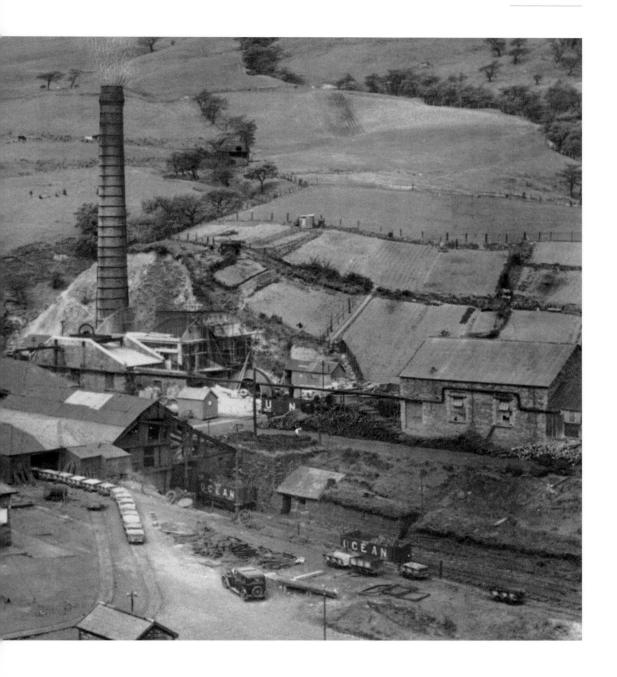

the week he stayed at Hummums, a famous old hotel in Covent Garden, well-known to Charles Dickens, among others. In *Great Expectations* Dickens gave Pip a night at Hummums. A parliamentary sketch writer wrote tongue in cheek that David Davies took some weeks persuading parliamentary attendants 'that he was not the carpenter come to ease a door or nail down the matting'. The writer added that 'all that has passed now and he is known in and out of the House as one of its most modest and most genuine members'.

The giants of the Commons were William Gladstone and Benjamin Disraeli. When David Davies spoke in the chamber of his pride in being a self-made man, Disraeli, the prime minister, said slyly that he was glad to hear him praise his creator. A Liberal MP later commented on David Davies's deep shrewdness and added that 'the self-esteem of the self-made man is beyond gauging'. Davies often presented himself in debates as a working man. In his maiden speech he spoke on temperance. Men drank too much, he said, because of high wages, cheap beer and convenient public houses; beer caused accidents. He recommended ten o'clock closing so that men might get to their jobs on time. Ivor Thomas, his first biographer, judged that Davies was 'not a great parliamentarian' and that 'the subtler graces of parliamentary oratory never came within his grasp'.

Parliament kept David Davies away from the hurly-burly of running his collieries. As steam coal production boomed in the 1870s he dashed off letters to managers in Cardiff and to Edward in Treorchy. When he visited the Rhondda a carriage met him at Ystrad station and took him to Treorchy where his company ruled. A brass band oompahed, pit boys held up lighted torches and the great man ascended to a platform to speak to the workers.

His idea that men and masters could be amiable comrades remained a theme of his life. As a younger man he had enjoyed the rugged comradeship of railway building. The coal industry was a very different matter, huge,

harsh and complex. Men in their hundreds toiled in deep passages where explosions, roof falls and flooding were commonplace dangers. Disasters in Rhondda pits killed 114 men in 1856, 178 in 1867, 100 in 1880, 81 in 1885. Wage disputes were bitter and frequent. In 1873 the hard-headed south Wales colliery owners cut pay by ten per cent and locked the miners out of the pits, reducing them to poverty so that they had no choice but to return to work for lower wages. A miners' MP wounded David Davies in 1875 by including him in a list of coalowners 'ruling in a despotic manner'. These owners, he said, were 'making war not only against the men but were infamously making war and bringing destitution upon the women and carrying misery and starvation to the children'. David Davies responded that he was 'sorry to see men in poverty and women and children starving'. But, he protested, 'it was not the fault of the masters'. All his life he had been 'a friend of the working man'. He saw, to his disenchantment, however, that the sort of amicable gathering he had addressed at his son's coming-of-age belonged to the past. He had once exulted in being a boss in a navvy's shirt. Now he was a boss at war with men he thought ungrateful.

# The family photograph

In August 1877 Edward Davies, aged twenty-five, married his first
cousin Mary, daughter of the Reverend Evan Jones, his mother's
brother. Edward and Mary had three children: David, born 11 May
1880; Gwendoline Elizabeth, 11 February 1882; and Margaret
Sidney, 14 December 1884, to whom Edward gave the pet name Daisy.
They were all born at Tempest Villa, later renamed Llwynderw, a house
on the edge of Llandinam. In 1884 the Top Sawyer bought Plas Dinam,
an elegantly proportioned mansion of charm and character, and gave it
to his son. Built on the site of an old parsonage it was a Victorian dream
of country house living. Edward and his young family moved into it in
March of 1886. The house had been built of stone and brick and completed
in 1873. The celebrated architect, William Eden Nesfield, a partner of
Norman Shaw in the 1860s, gave Plas Dinam the romantic Gothic look
of a house of the late middle ages. During the 1870s he also designed
houses elsewhere in Wales, opulent Kinmel Hall in Denbighshire and
Bodrhyddan in Flintshire. Plas Dinam reflected the Davieses' social status
and industrial success. Nesfield gave it a large porch with a Tudor stone
arch inscribed Pax Intrantibus, Exeuntibus Salus, wishing peace to visitors
and a safe journey to those departing. From its lawns and windows there
is a serene southern prospect of meadows, trees and hills along the Severn
valley towards Llanidloes. In a journal she kept when she was twelve
Margaret Davies wrote of Plas Dinam as 'Home Sweet Home.' For its

setting and storybook quality she and her brother and sister always loved it.

Their Victorian upbringing was not unlike the Edwardian childhood Eiluned Lewis described in her autobiographical novel, Dew on the Grass. She grew up in a middle-class family near Newtown and related how it dawned on the children that there existed a different world to the south, the Wales of the coalfield and social and industrial turmoil. They heard staff at a railway station shouting: 'Change here for South Wales!' and realized that 'there actually is a train waiting to go to South Wales – that unknown country'.

From Plas Dinam the Top Sawyer's grandchildren could see his home across the Severn. The old man would hang a towel from a window upstairs to call them to tea. On their way to his house they passed the station on the Llanidloes-Newtown railway he had built in 1859. The station was for a century the hub of Llandinam bustle. It closed in 1962. In Victorian

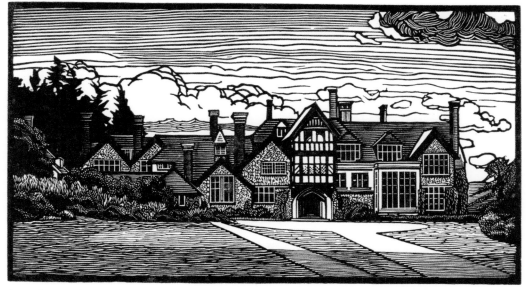

Sweet home: wherever she travelled Margaret kept a corner in her heart for the Montgomeryshire hills and Plas Dinam. She made this woodcut in the 1920s as a tribute

and Edwardian times horse-drawn wagons crowded the yard and men loaded them with coal, lime, bricks and animal feed. If the Llandinam foxhounds were to hunt around Newtown, or beyond, dogs and handlers arrived early to catch the 6.40 train. Pony traps clattered in to pick up passengers. Others came to collect the daily newspapers, individually wrapped and addressed for Plas Dinam, the coal merchant, the clergy, the postmistress and others. The cost of The Times might be shared by three families. The stationmaster and his friends digested headlines and discussed Liberal party fortunes. Edwin Jones, the headmaster, called for his Manchester Guardian and returned with it to the school where he lit his pipe and read a selection of news to his pupils, salted with his own running commentary.

Two chapels and a church ruled Sundays in Llandinam. The Calvinistic Methodist congregation was invariably larger than the Wesleyan. Servants from the 'big houses' swelled attendances. Church congregations were smaller. On Monday mornings the vicar's wife toured the parish on horseback calling on those who had been absent from church. One Sunday, two men were spotted returning to Llandinam on a train early that day and were censured from the Methodist pulpit for transgressing the sabbath.

At sixty-five David Davies embarked on his last battle, leading the Rhondda colliery owners in their long campaign to break Lord Bute's monopoly over coal exports. Lord Bute owned the port of Cardiff which shipped out more than seven-tenths of the coal mined in south Wales. The very word Cardiff on a shipment of coal was a mark of quality. The Rhondda owners complained of chronic congestion at Cardiff docks and of the railway company's high charges for carrying coal from the collieries to the ships. They petitioned for an act of parliament to build a new dock at what was then the hamlet of Barry, eight miles south-west of Cardiff. The scheme included a railway linking the Rhondda to Barry, and the

mine owners insisted that both dock and railway should be under their control.

They won their case in 1884 and David Davies triumphantly grasped a spade, spat on his hands like a navvy and dug the first sod. His speech at the inaugural banquet in July 1889 was one of his last public appearances. He died a year later. In 1901 Barry outstripped Cardiff in the tonnage of coal it sent out to the world: in other words it became the world's top coal exporter.

The town grew rapidly into a resort and a legendary place of summer pleasure and day trips for coalfield families. In the long run the existence of large docks at both Cardiff and Barry encouraged colliery owners to increase coal production and overreach themselves. Output eventually reached unsustainable levels and ensured that the depression of the 1920s was more painful than it might otherwise have been.

In 1885 the Top Sawyer and fourteen of his clan gathered for a photograph at Edward Davies's home in Llandinam. All the players in the dynastic saga of the family fortune were in the frame. In the front sat David Davies, sixty-six years old, his beard a white Old Testament bib. His five-year-old grandson and namesake wore a sailor suit and leant against his knee. His granddaughter Margaret was in her first year and sat beside him on her grandmother's knee. His three-year-old granddaughter Gwendoline sat at the back with her mother, Mary. Mary's sister, Elizabeth Jones, was on the garden bench next to David Davies. Evan Jones and David Lloyd Jones, Methodist ministers, formed a reverend bookend on each side of the group.

As the photographer worked, Edward leant with his back against a wall on the left of the picture, his hands in his pockets. He had a thick and concealing beard. He seemed to be gazing pensively into the middle distance. At thirty-three he was sole heir to his father's wealth and felt the weight of it. In April 1888, three years after the photograph was taken, his

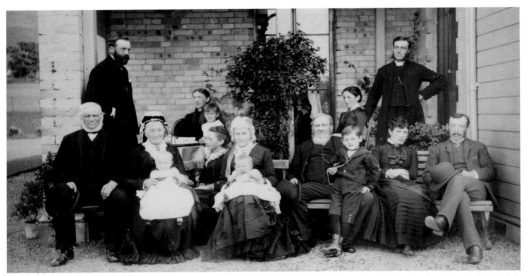

Top Sawyer's family, 1885: David Davies, centre, with sailor-suited grandson David. Son Edward stands left, his first wife Mary next to him with daughter Gwendoline on her knee. Elizabeth Jones, who will be Edward's second wife, sits next to young David. By her side, Edward Jones. At the back, right, Annie Lloyd Jones and husband, Rev David Lloyd Jones. In the front, left, Rev Evan Jones and wife Elizabeth who holds grandson John Lloyd Jones. Next to her sits Margaret Jones. Beside her, Margaret Davies, Top Sawyer's wife, holds baby Margaret, Gwendoline's sister

wife Mary died at the age of thirty-eight. People remembered that in the following days her six-year-old Gwendoline had asked if her mother were in heaven. Given the answer: 'Yes, of course,' she had responded: 'Then why is everybody crying?'

Mary's younger sister Elizabeth took on the responsibility of filling the empty space in the family. After four years she and Edward wished to marry, a not uncommon situation. Many a widowed man desired to rebuild his family in this way, but the law forbade a marriage to his late wife's sister, a restriction in keeping with church doctrine. For almost sixty years, from 1849, bishops in the House of Lords defeated the many bills seeking to legalize such marriages. In their operetta Iolanthe, which opened in 1882, Gilbert and Sullivan echoed the frustration of widowers. Infuriated by the stubborn bishops the Queen of the Fairies sends the

His energy conquered time and distance. In February he went by rail from his home to Builth Wells to discuss a new college scheme, took the train to Treharris, had tea at Bargoed, gave a lecture and reached the Ocean Coal offices at Treorchy at 10.30 p.m. Next day he was at an Ocean board meeting, went by rail to Nantymoel, lectured in aid of a chapel, and walked four miles over the mountain back to Treorchy, arriving at 11.30 pm. On 3 March he went to London where 'I have great altercation with cabby, who eventually threatens to prosecute me. Tell him to go to hell.' During a week's military training at a camp

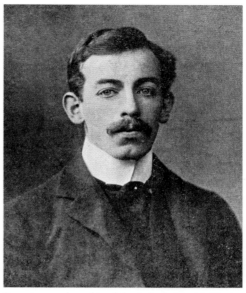

Seventeen when his father died, David Davies became the squire of Llandinam, heir to wealth, power and responsibility

in Wiltshire the relentless callous jokes of his companions, their foul language and drunkenness appalled him. In March he met his sisters in Switzerland. He was still there in April and was treated for a sore throat by a Dr Gamgee, 'a dreadful old humbug' and an 'old rotter'. The hotel staff's command of languages impressed him. 'Both the waiter and maid speak three languages. What a drawback to be born on an island.'

In August, aged twenty-four, he sailed from Liverpool to New York, on the first leg of a journey around the world. He noted several card sharpers on board and heard steerage passengers singing a hymn in Welsh. A shipboard romance with an attractive girl called Ruby Milne gave wings to the ocean days. 'Ruby looks blooming,' he noted in his journal. 'Ruby is most fascinating but I don't really love her.' 'What lovely eyes and beautiful figure. I wish I could fall hopelessly in love. She is evidently fond of me.' 'Chat with Ruby. Very exciting evening. Can't sleep – the situation is full of pain and romance.' As a cooling counterweight he

ploughed through a biography of Gladstone which 'makes one heartily ashamed of oneself'.

In New York he found 'Ruby in great form'. They met again in Montreal. He recorded that 'the situation is becoming more acute, a proposal is impossible just now. A promise to Ma and crowds of other reasons. She is very fascinating and my attachment is constantly growing into something else'. After breakfast next day he walked with Ruby in Mount Royal park and after dinner they had 'a delightful tête-à-tête, the moonlight streaming through the branches. I endeavour to explain my position and we arrive at a sort of understanding, not satisfactory to either of us!'

He went off to hunt with friends in Quebec and received 'a charming letter from Ruby which is read and re-read'. Back in Montreal he dined with Ruby and her parents 'until it is time to go to the station, saying goodbye is a terrible ordeal'. At last he headed west for weeks of camping and big game hunting on the Canadian frontier. He enjoyed Canada so much that he bought a ranch near Edmonton, Alberta, in 1907 and owned it until 1918. He called it Merchiston, after his school.

From Vancouver he crossed the Pacific, punctuating his days with games of deck cricket and hockey, and landed at Yokohama on 18 October. In Tokyo, at the start of his three months in Japan, he was one of the handful of westerners who saw something of the Russo-Japanese war of 1904–05 which led to the defeat of Russia's forces and Japan's emergence as a world power. He stayed at the Imperial Hotel in Tokyo where most days ended with 'dinner, pills and so to bed'. On 22 October he wrote: 'Defeated by Lord Anson at pills after dinner.'

He rode and hunted in the winter snows, hoping but failing to shoot a bear. Impressed by the elegance of Japanese tea houses he ordered one for Plas Dinam. At Yokohama he received 'an extravagant epistle from Ruby'. In Tokyo geishas led him to dinner with Japanese academics where he found 'everything hopelessly mixed up together, soup, fish, fowl, vegetables. The professors put a great deal of sake out of sight, and Mr Okuma, who is evidently fond of his glass, is more or less blind before

the second part of the dinner arrives'. He found the geishas 'modest and retiring, perfect ladies'; and met Princess Nashimoto, 'extremely pretty – a perfect beauty – have never seen anything to compare with her complexion and eyes'. He described a British woman he met as 'tall and handsome but has a reddish tinge about her nose. This may be fancy on my part'.

On Christmas Day he sailed from Nagasaki to Korea and stayed in Seoul before going on to China. He wrote tersely of three nights in a hotel in the port of Tientsin: 'Owned by a Chinaman, and managed by an Austrian who is a swine of the first water.' He travelled home to Wales by way of Shanghai, Hong Kong, Saigon, Singapore, Colombo and Marseilles.

❧

He at once directed his energies to his estate. In 1905 he founded the David Davies Hunt, bred a pack from English and Welsh hounds and hunted hard, testing the endurance of huntsmen, horses and hounds. He also ran packs of otter hounds and beagles and entertained friends to his game shoots. He quickly made a difference to agricultural practices on his estate and became a founder and funder of the Welsh National Agricultural Society. He encouraged farmers to join him in improving their livestock and kept a bull, a stallion and a boar to strengthen native breeds. Without his enthusiasm the distinctive Welsh Black cattle, Welsh cob horses and the Welsh pig might have dwindled to extinction.

David Davies was a hunting and shooting countryman all his life – 'it was one of the things that made us love him so much,' a friend said, 'he was a boy to the end'

In 1906, aged twenty-six, he became chairman of the Ocean collieries and Liberal MP for Montgomeryshire. In the election of that year the great Liberal wave washed away the Tories in Wales. The Liberals took all thirty-four Welsh seats except for the second seat in Merthyr Tydfil, won by the Labour pioneer Keir Hardie. Those were the years of the rising fortunes of David Lloyd George, of prosperity in the pits and record congregations in the chapels. In 1906 Nonconformist membership in Wales reached 549,000. Industrial disaffection lay ahead, but for the time being the loyalty to Liberalism and the chapel made Wales seem relatively peaceful and united. In a patriarchal society suffragette protest caused much less disturbance than in England, although men in Wales sometimes reacted to it brutally when they encountered it.

David Davies's election to parliament was a curious Montgomeryshire affair. He assembled a bundle of policies drawn from Liberal and Tory thinking and stood with the endorsement of both parties to gain the seat unopposed. 'Even the good people of Montgomeryshire didn't know quite what to make of that young man,' a friend remembered, 'whether he was going to be a Liberal or a Conservative.'

His parliamentary persona was that of a squire of the old and independent Georgian gentry. Certainly he was an odd sort of Liberal. There was something of his grandfather in him. He believed in speaking his mind, voted as he thought fit and disagreed with his party's views on almost every question. From the start he was largely inactive in parliamentary politics for he disliked debating in the Commons and had scant interest in Westminster procedures. Ever a get-things-done man he was peppery about the slow turning of democracy's machinery. He certainly expressed vigorous views on the relationship between landowners and their tenants and he voted against many of Lloyd George's land reform proposals.

His staff of secretaries and retainers helped him to run his political and public affairs. As president of his constituency Liberal party he paid six-sevenths of its income and was content to see it wither into inertness. A maverick in Westminster, he was safe in his fiefdom in Wales.

Montgomeryshire liked him and a local newspaper explained that the farmers had adopted 'the cult of David Daviesism'.

One of those who worked for him observed that although he was chairman of a major coal company and had other directorships he was not really fond of business at all. 'He did all these jobs with his usual high sense of duty but I don't think he was genuinely interested in them. He rather grudged the time he had to spend at them.' On the other hand his commitment to the family tradition of philanthropy was complete and enthusiastic. In this he and his sisters were united. He himself was said to lead a 'life of furious beneficence'. In 1907 a magnificent chemistry laboratory, funded by the Davieses in memory of their father and of his dream of a career in science, was opened at the college in Aberystwyth. As vice-president of the college, David also endowed a chair of colonial history. Meanwhile he and his sisters gave generous support to the infant National Library of Wales founded in 1907.

He believed in his own 'brainwaves' and was never short of them. He embraced all new technology. In 1912 he installed a water-powered turbine to generate electricity for Plas Dinam and its estate office and timber workshops. He also supplied houses in the village, and charged people a shilling a year for each light bulb they used. A local McGonagall marked the arrival of the future:

> All ye who roam about at night
> In villages without a light,
> Ruing each other's hapless plight,
> Take notice of Llandinam.
> The squire of that so famous spot
> Has lightened all the people's lot
> There's not a morsel to be got
> Of darkness in Llandinam.

The Davies turbine brought light to the Methodist manse and the rectory. The artist Sir Kyffin Williams remembered that Llandinam, 'still almost

feudal, was lorded over, benevolently but puritanically', by David Davies who switched off the power and darkened the village 'at an annoyingly early hour'. Sir Kyffin also recalled that under the Davies rule Llandinam's hotel did not serve alcohol and that on 11 August, the eve of the shooting season, guests arriving at the temperance hotel smuggled in crates of drink and secreted them in the dining room.

*Chapter 6*

# Upbringing

s was the custom for girls of their class, Gwendoline and Margaret were schooled mostly at home. Their stepmother may have taught them to read and write and a tutor may have called at Plas Dinam to teach other subjects like drawing and arithmetic. The journals they wrote when young were composed in clear and fluent handwriting with a good vocabulary. As they grew up they attended morning and evening services at their chapel in Llandinam and Sunday school as well.

Higher education for girls was still strongly resisted at that time. Some academics asserted that mathematics and Latin and Greek were too hard for them. Doctors warned that 'strong brain work' could cause reproductive disorder and advised that menstruation was a barrier to intellectual activity. Certain clergymen damned university education for female students as unchristian and branded Girton, the first women's college at Cambridge, an 'infidel place'. In the 1890s men set fire to effigies of women and pushed them through Girton's gates.

In 1895, when Gwendoline was thirteen and Margaret ten, their father and stepmother hired a governess to teach them. In late Victorian Britain about 25,000 governesses lived in the homes of the well-to-do. Many of them taught the piano and French; and those who had learnt French in Paris were sought after for their better accent. Florence Nightingale's

father instructed his daughter in Latin and Greek and paid a governess to teach her music and drawing.

A governess in the home could present a dilemma. The wealthy, the middle and upper classes, knew where they were with their servants. For their part the cooks, maids and grooms knew their place, too. Governesses, however, were neither family nor servants and occupied an awkward niche between upstairs and downstairs. It was a matter of caste. Their standing in society was questionable; and servants often found them snooty. Some governesses were tormented by shrewish wives and insolent children and spent unhappy evenings alone in distant rooms. As single women, educated yet working, they were curiosities; and, if attractive, they might be thought threatening. The contradictions of their existence gave rise to a governess literature. Anne and Charlotte Brontë, for example, drew

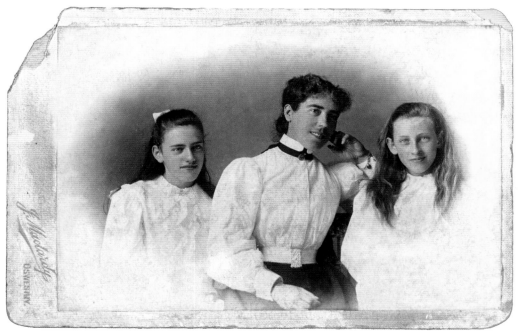

Woman of confidence: Jane Blaker, with Gwendoline, left, and Margaret, came to Plas Dinam as governess in 1895 and stayed as teacher and companion until her death fifty-two years later

their daughters to go unescorted, even with their fiancés. The social life of Gwendoline and Margaret was carefully monitored. Calvinistic Methodism frowned on ostentation and such frivolity as dancing. Lawn tennis, however, a game invented at a country house in north Wales in the 1870s, was a permitted recreation and both sisters played it. They went to social gatherings at shooting lodges in the neighbourhood and often met their cousins Edward and Ivor Lloyd Jones, sons of the Reverend David Lloyd Jones of Llandinam. Their brother David introduced them to his university friends. They also had their riding acquaintances.

The sisters therefore circulated within the fairly small and protective orbit of their family and chapel, which was a profound force in society. It was a world that Jane Austen, the spinster daughter of a country parson, would have recognized. The Davieses had many connections with clergymen and such men of renown as John Jones Talysarn, a leading preacher of the nineteenth century. Clergy called often at their home. In this little world any step towards marriage would have been taken, and carefully arranged, within the chapel milieu. No outsider would have been a contender.

The Davieses' devotion to their faith was an aspect of their distinct social stripe. They were Welsh chapel, not Anglican; Liberal, not Tory. They were not 'old money'. The Top Sawyer, Welsh and Welsh-speaking, was new money. His great wealth elevated him not to the aristocracy, but to an elite, the landowning gentry. At the same time the extent of his fortune set him apart in a financially modest rural middle class.

Edward Davies's death in 1898 raised at an early stage the question of how the sisters would live with the weight and predicament of wealth. In her view of the sisters' lives Eirene White said that according to rumour 'both young women had one or two potential suitors but their personal standards were exacting, and they were well-protected by their own shyness and their two dragonesses'.

The sheer size of the sisters' inheritance actually narrowed their prospects of marriage. Although they disliked pictures of themselves, and never had portraits painted, their photographs reveal perfectly

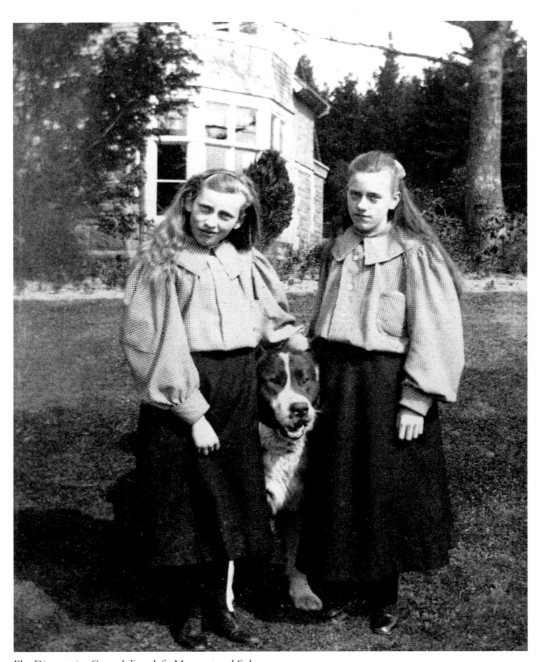

Plas Dinam trio: Gwendoline, left, Margaret and Sultan

presentable girls and it was not surprising that young men awarded them glances. Their wealth, however, was a moat and their stepmother guarded the drawbridge. By all accounts she feared fortune hunters and took steps to protect her stepdaughters. She would hardly have believed any man who protested that money was unimportant to him. In 1911 thirty-one-year-old George Maitland Lloyd Davies got to know Gwendoline, his cousin by marriage. His strong-minded mother thought she might be suitable for her son. He, however, was frightened by Gwendoline's wealth, grew to disapprove of the rich, and preferred to be free. He became engaged to another girl and felt painfully guilty whenever he thought of Gwendoline.

In any rich family possession of money was freighted with obligation to dependants, charities and good causes. Whatever their thoughts of romance Gwendoline and Margaret understood that the Top Sawyer's patrimony carried an overriding responsibility. The immensity of the fortunes frightened them. They had seen their father devastated by anxiety over money. Perhaps they heard their stepmother say, as she said to a friend: 'You would never grumble about having too little money if you knew what it was like to have too much.'

For the Davieses their fortunes were also a covenant. They understood very well the realities of the source of their inheritance and of the human price of coal in the Rhondda. It made them feel indebted. In forty years from 1874 to 1914 more than a third of British colliery deaths were in south Wales. After 1900 coal production and the number of deaths increased. The Top Sawyer's grandchildren grew up in the Calvinistic tradition of social conscience. They had a public-spirited outlook, an interest in social matters, education and music and literature. The age in which they lived was a time of investment in education and the founding of national institutions in Wales, the idea of a new Wales. They, too, shared the belief of Andrew Carnegie, the American steel tycoon, that the rich were morally bound to give money to the public good, that a fortune should support universities and libraries and be a ladder for the aspiring. Gwendoline and Margaret knew that a lifetime of charitable

work lay ahead. They could not know how incessant and pressing the demands would be.

In their circumstances, and with the passage of time, they may have seen a simplicity and an inevitability in remaining single. They needed no husbands for financial support. In a man's world they necessarily had to work through the agency of men; but that in itself was no compelling reason for marriage. Within their family and social circle they had the influence and example of independent-minded women. Their grandmother Margaret Davies, who had died aged eighty in 1894, embraced the Methodist church in defiance of her father. For all the Top Sawyer's wealth she retained an exemplary humility and made 'no distinction between rich and poor'. Elizabeth Davies was ever a resolute figure in the sisters' lives and kept bright the memory and qualities of their father who had sacrificed his dream of scholarly research to run the family collieries. Formidable she may have been, but she was the devoted and admirable head of the family. In the sisters' own home, too, there was the example of the loyal, self-sufficient, unmarried and permanent Jane Blaker.

Gwendoline and Margaret matured within their own close relationship, their companionship and their shared emotional experience, the loss of parents, for example. As they grew they were often regarded as a unit, a pair, 'the girls', 'the sisters', almost as if they were twins; but their characters were different. They were in the same boat but Gwendoline emerged as the leader, the originator, more adventurous, more outward-looking, her writing more effusive. She was always readier than her sister to pour her feelings into journals and letters. She reacted spontaneously and found release in the flow of ink, recounting joy and frustration, the ebb and flow of emotion. Margaret was self-contained and objective where her sister was subjective. Gwendoline blew her top. Margaret never did.

They stayed single because they were married to the family tradition of duty, in keeping with their Calvinistic beliefs. In the circumstances there never was, for either of them, an ideal husband on the horizon. As single women they retained their sense of purpose and were independent

From the beginning they had advice from Hugh Oswald Blaker, a personable man–about–art quite unlike most of the men who entered their enclave at Llandinam. As the younger brother of Jane Blaker he arrived, of course, positively vetted. There is no record of his meeting the sisters before 1908 but it is quite likely that he did so. He was born in Worthing in December 1873 and schooled at Cranleigh in Kent. In the 1890s he studied at the Académie Julian in Paris and the Antwerp school of art. The best-known photograph of him is the informal picture taken in the early Edwardian years when he was in his late twenties. He strikes a rather raffish pose. Clean-shaven and firm-jawed, he looks over his right shoulder and candidly engages the camera across his turned-up coat collar. The pose and the certain smile are reminiscent of the brilliant self-portrait painted by Sir Anthony Van Dyck in 1640. Blaker's cap and his backward glance suggest a jaunty confidence and a peppershake of vanity. The cap fits.

Blaker was a collector, connoisseur and critic who described himself as an artist and was, indeed, an accomplished painter. In his career he followed no single furrow and hopscotched between galleries, studios and his writing desk, a talented man who perhaps cast his skills too widely, as he himself later admitted. As a cultural combatant and fiery writer he attacked narrow-mindedness, hypocrisy, the influence of the church, the smugness of the rich, bad housing and sanitation, the oppressions of child labour. Hostility to accepted ideas, he wrote, should be taught in schools.

He revelled in the excitement of the new in French painting. In the art battles he wore his passion as a panache and fought on the modernist side, ever ready to shout Yes as his opponents cried No. He would have approved of George Bernard Shaw's words at a meeting of the new National Art Collection Fund: 'We must continually remind our rich classes not only that we want more money but that they owe it to us.' Blaker made much of his living as a respected dealer in pictures and scorned ponderous scholarship, preferring to act on intuition, what he thought of as his flair. He was a stranger to doubt. He certainly had his coups, picking out grimy pictures as masterworks; and, of course, he also made mistakes.

In 1905 he had been appointed curator of the Holburne of Menstrie museum in Bath. David Davies had stood as his guarantor. Founded in 1893, the museum housed the paintings, ceramics and other antiques of Sir William Holburne, of Swansea, a veteran of Trafalgar. Blaker immediately reviewed its 258 pictures. He and a colleague judged eleven as very good, thirty-three good and fifty-nine fair. They dismissed the remaining 155 as bad and consigned them to the cellars. Blaker himself informed the press of this massacre. It earned him both censure and approval. Later he summoned the Bath council art committee to rebuke them for their proposed purchase of a 'horrible' picture. 'The councillors raved for it,' he recorded in his diary. 'I won't have it and will stop the purchase. I am Art in Bath.'

When the Davies sisters' interest in painting grew into a serious pursuit Blaker was, through Jane Blaker, on hand to advise them. In a memoir written in the 1930s the artist Murray Urquhart said generously that his friend Blaker was the architect and inspirer of their collection. This was, perhaps, an exaggeration but Blaker was modern-minded and talented and pointed the way towards his beloved Impressionists. He certainly had an ambition to play a part in the creation of a famous collection and he put his stamp upon it. A version of Svengali he was not. Gwendoline and Margaret sought his advice but they made their own decisions.

Their purchases reflected the tastes of two quiet and unassertive women who enjoyed a travelling art education. They liked landscapes and insights into country life. They did not, with some exceptions, buy pictures of busy railway stations, of people dancing in the park, drinking in cafes or walking in the streets, going to the races, lunching or having picnics. They purchased no paintings of women stepping into baths or nude on a river bank. They responded to their own feelings and bought pictures entirely to please themselves, the work of artists they had studied and admired, paintings of places they had visited and loved: hence their liking for scenes of Venice. It was an aspect of their independence. As Gwendoline put it in January 1925: 'The great joy of collecting anything is to do it yourself – with expert opinion granted, but one does like to choose for oneself. All

Monet                                                    *San Giorgio Maggiore by Twilight* 1908
Gondolas skiffed Monet and his wife Alice into the gloaming

the time we have been collecting our pictures we have never bought one without having seen it or at least a photograph before purchase.'

Hugh Blaker was their necessary agent and dealer in the labyrinths of art. This was his world, a man's world. He knew what would be coming up in auctions, how to locate pictures, how to import them. When he saw something the sisters might like he pasted a photograph of it on a card and sent it to them in the post. Working for the Davieses, 'the girls' as he sometimes referred to them, he embraced his role as go-between in an exciting and imaginative endeavour. As he candidly told them, it enhanced his status in the galleries and sale rooms. His influence in the birth and growth of their collection was significant but he was by no

means the only adviser. There was also Murray Urquhart. Another was the dealer and critic David Croal Thomson who worked at a gallery in Paris and was a friend of the artists James Whistler and Philip Wilson Steer.

Croal Thomson was also a friend of the art dealer Paul Durand-Ruel, a supporter of Impressionist painters from the early 1870s, who bought and sold works by Monet, Renoir, Pissarro, Manet, Degas and others. Durand-Ruel encouraged them to paint pictures he knew he could sell. The second Impressionist exhibition, in 1876, was held in his Paris gallery; and ten years later he staged the first Impressionist exhibition in New York.

He also had a gallery in Covent Garden and observed the London art market. Here, too, critics pursed their lips and grumbled that modern French painters betrayed art's classical roots. Reviewing an Impressionist exhibition in London in 1883 The Times warned of 'the Extreme Left in painting flying in the face of tradition'. The Illustrated London News was shocked by 'roughness and violent contrasts of bright light'. The Morning Post saw 'mirth-provoking' pictures. Nevertheless broader minds admired the Impressionists for their commitment to spontaneity. The St James Gazette commended 'the restless flutter, the momentarily changing passions and fashions'. The Standard welcomed 'a modern school of undoubted importance'. Still, a London saleroom crowd in 1892 took one look at *The Absinthe Drinker*, a cafe scene by Degas, and promptly hissed it; and a critic called it 'a study in degradation'.

Things were little better in 1905 when Durand-Ruel exhibited paintings at the Grafton Gallery in London: fifty-nine by Renoir, ten by Cézanne, fifty-five by Manet, nineteen by Monet, thirty-six by Sisley, forty by Pissarro and thirteen by Morisot. Large crowds saw this stellar show but it was a commercial failure: of 315 pictures exhibited only ten sold.

The British taste in art was for the classic landscapes and portraits of the eighteenth and nineteenth centuries, for Thomas Gainsborough, Joshua Reynolds, George Romney and John Constable. Around the turn of the

Millet

*The Goose Girl at Gruchy* 1850s

Millet's nostalgic study of his birthplace village near Cherbourg

wrote. 'The shops are filled with postcards and music and every window seems to have something of Wagner to show.' They had tickets for Das Rheingold and in a few words Margaret sketched the audience: 'French, Austrian, English and American, some dress very gaily with many a frill and feather.' The performance delighted them. 'We are left to dream and wonder at it all.' They made a pilgrimage to Wagner's grave and saw Siegfried Wagner, his son, conduct Lohengrin. They completed their holiday with an old-fashioned coach trip in the pine forests near Nuremburg, their luggage 'packed behind a merry coachman and two good horses with bells'.

Camille Corot 1796-1875    *Castel Gandolfo, Dancing Tyrolean Shepherds* 1855-60
The sisters admired Corot's effect of tremulous light. Gwendoline bought this in 1909

In London in October Gwendoline bought the sisters' third Corot, *Castel Gandolfo, Dancing Tyrolean Shepherds*, for £6,350. A picturesque landscape of the castle on Lake Albano, south of Rome, it was painted around 1855-60. In due course it reached Llandinam by train. The sisters bought twelve paintings in all in 1909 and spent £18,739.

❦

In January 1910 Hugh Blaker recommended the purchase of three Turner oils for £4,000. He wrote from Bath to Gwendoline and enclosed the telegram of acceptance of the offer. His sister Jane, perhaps unfairly, had warned him that the confidentiality of telegrams to Plas Dinam sent via Llandinam post office could not be guaranteed. He therefore wrote in his covering letter: 'I did not mention the amount in my telegram for fear of the village gossips who, my sister tells me, are always very much alive to such matters. I am delighted you have bought (the Turners). You certainly have one of the most interesting sets of pictures in existence.' The sale was a close-run thing: a partner in the Dowdeswell gallery in London had already set off with the Turners for America but the ship called at Queenstown in Ireland and they were retrieved and brought back to London. 'We were just in time,' Blaker said.

Alerted to Margaret's interest in the works of the fashionable Jean-Louis-Ernest Meissonier Blaker found *Innocents and Card Sharpers* and Margaret bought it in March 1910 for £5,250. The price reflected the artist's popular reputation. Meissonier specialized in exquisite and minutely detailed paintings and won the highest awards. This one is full of drama: men in the costume of The Three Musketeers are gathered edgily around a table, ready for violence as they watch the fleecing of two beardless youths, their helpless prey.

❦

In April 1910 David Davies married Amy Penman, of Lanchester, Durham. Medina Lewis described her as 'a beautiful girl with a lovely oval face and blue eyes, a sportswoman, a rider to hounds. David fell in love'. The couple sailed to east Africa for their honeymoon; and David hunted big game, returning with his trophies to adorn his walls.

He invited his old school friend, Murray Urquhart, to paint his hounds and horses. During his three months at Llandinam Urquhart became a friend of Hugh Blaker. They attended art sales together and Blaker impressed Urquhart with his 'unerring flair' for identifying old masters through layers of dirt. The friendship they forged lasted until Blaker's death.

David Davies later commissioned Urquhart to paint a mural celebrating Owain Glyn Dŵr, the national hero who led a revolt against English rule early in the fifteenth century. The mural is in the Glyn Dŵr institute in Machynlleth. Urquhart depicted Glyn Dŵr as a triumphant warrior and awarded him David Davies's unmistakable face and moustache.

In June 1910 Blaker bought Millet's *Shepherdess Knitting* and *The Good Samaritan* for the Davieses. *The Good Samaritan* is a small moonlit scene of a peasant supporting a staggering companion. Gwendoline took the biblical title at face value and bought the picture before seeing the Wallis gallery's catalogue note that the stumbler was inebriated. During June and July Blaker acquired for the sisters three more oils by Corot: *Distant View of Corbeil, Morning*; *Etude de Paysage*; and *A Lake at Sunset*.

In July Blaker wrote to the sisters from Bath returning a cheque they had sent him for his services. 'I should be awfully pleased,' he explained, 'if you will allow me to do any little service of this kind without remuneration. My obligations are always so overwhelming, and it is always a great pleasure and of great interest to me personally – and it is doing me a lot of good in the picture world. I should look upon it as a great favour if I may return the cheque. Until my affairs are straightened out I feel I cannot accept any further kindnesses.'

❧

September 1910 promised adventure. The sisters, their stepmother and their schooldays friend Evelyn Herring went by rail to Cologne. Here the reassuring figure of Archibald Harrington, their chauffeur, waited with the family's chocolate-coloured Daimler. The British flag flew on the bonnet. On the International Travelling Pass Elizabeth Davies was registered as the car's non-driving owner. As soon as the luggage was packed the party set off for Bavaria, the very picture of intrepidity, first of all following the Rhine to Koblenz. Ever the landscape patriot, Margaret remarked in her journal: 'Personally I like some of the scenery one gets on the banks of the Wye or Severn much better.' They drove through the Black Forest into Switzerland and along mountain roads. From time to time Mr Harrington mended punctures.

They returned to Bavaria and drove to Oberammergau to see the Passion Play performed by the local population every tenth year. Edward Lloyd Jones, the sisters' cousin, joined them there, and also two of their aunts and Jane Blaker. Margaret described the excitement of the crowd. The enactment of the Last Supper and Christ's Entry into Jerusalem moved her; but she reacted strongly to the Agony in the Garden and the Trial and Crucifixion, finding the scenes uncomfortably distasteful. 'No mortal man,' she wrote, 'should attempt such a thing.'

The Llandinam party made their way into Italy and drove beside Lake Garda to Verona, Mantua and Bologna where the sisters and cousin Edward picked grapes. They travelled to Rimini on the Adriatic coast, then to San Marino and made their way to Milan to take a train for home.

Roger Fry, the painter, critic and member of the Bloomsbury group of artists and writers, staged an exhibition in London in November 1910. The reaction to it demonstrated the embedded intensity of feeling about Impressionism. The art historian Wilfrid Jasper Blunt wrote scornfully in his diary of 'works of idleness and impotent stupidity, a pornographic show'. A psychologist's diagnosis was that the artists were mad. The

Times critic was appalled by Fry's 'subversive' exhibition, the 'blatant disregard for skills past artists had acquired, a blatant rejection of all that civilisation had done'. Such critical contempt undoubtedly reflected the establishment's view.

In his journal Hugh Blaker, who 'held in reverence all that was great in Art', declared the exhibition one of the diversions of the season. 'The Press, headed, of course, by the ponderous stupidity of The Times, derides it. Even some superb Monets are ridiculed. Gauguin, Cézanne are mere incompetent clowns! thus proving that cultural London is composed of clowns who will, by the way, be thoroughly ashamed in twenty years' time and pay large sums to possess these things. How insular we are still.'

Turner    *The Morning after the Wreck* 1840s
Turner drew on his experience to compose his scene of beachcombers searching the wreckage of a ship

In that month of November Gwendoline paid £6,000 to the Dowdeswell gallery for Turner's oil *Morning after the Wreck*, painted in 1840. The scene is an imagined shipwreck on Margate beach, with scavengers picking what they can. In the distance a ghostly, barely-visible, silhouette of a ship under sail disappears into the mist, perhaps sailing into history. In December Gwendoline bought the eighteenth-century portrait *Elizabeth Douglas of Brigton* by Henry Raeburn for £6,300. The sisters spent £30,040 on eighteen pictures in 1910, their third year of serious collecting, and they now owned thirty-seven. They were yet to buy an Impressionist painting.

Meanwhile, in November, Winston Churchill sent troops to Tonypandy in the Rhondda in the wake of rioting by striking miners. The bitter troubles marked the beginning of a new militancy in the coalfield, and the struggle for a minimum wage.

# Chief and Microbe

n the summer of 1910 the Reverend Richard Jones, the Calvinistic Methodist minister at Llandinam, introduced a former college friend to David, Gwendoline and Margaret Davies. His old classmate was Thomas Jones, then almost forty years old and the professor of economics at Queen's University in Belfast. He and his wife were spending a holiday at the manse in Llandinam. In his autobiography Tom Jones recalled the happy meeting with the three people he dubbed 'the coal magnates' and noted that 'almost casually, we began a life-long and fruitful friendship'. Over four decades of the twentieth century this industrious public figure and Downing Street mandarin also played his ambitious and constructive part at the heart of the Davies saga.

The Davieses were millionaires, David just thirty, Gwendoline twenty-eight, Margaret twenty-five. Tom Jones was a have-not working class boy from the Rhymney valley in Monmouthshire. He had left school at fourteen and had propelled himself into the educated middle class that grew in Wales from the 1870s. He had a reforming outlook; and he not only pondered, he acted. 'Never in his life was he satisfied with the Celtic penchant for supposing that words were enough,' observed his daughter, Eirene White. His lifelong passion was the development of higher education and he championed the Workers' Educational Association. In a speech in 1910 he advocated the founding of state-run medical care. His

it on the pompous notions of George Bernard Shaw and others. When her husband conceded with reluctance, that he would become a parent she gave him an ultimatum in writing: 'I will not accept children from you if you only "yield", not even if you "acquiesce". Unless I succeed in making you actually wish for them we remain in status quo. Let there be no talk of "yielding" to my wish. I won't have that sort of co-operation at any price. That's final and definite and you needn't refer to it again.'

That was in 1907. In 1909 their daughter Eirene, the first of their three children, was born. She became a Labour MP and a Deputy Speaker of the House of Lords.

Although his wife converted Tom Jones to fatherhood she failed to persuade him to care much for his appearance. She complained that he wore his suits until they shone like mirrors. On his arrival as a new civil servant in Whitehall one of his superiors took one horrified look at his battered bowler hat and commanded him to buy a new one. Some time later the shabbiness of another of his hats prompted the chief of the civil service to seize it from his head and cast it into the sea from the deck of the liner Mauretania. Tom Jones often seemed physically, as well as sartorially, uncoordinated; and he was in that tiny minority of Welshmen who cared not a jot for sport. The Davies sisters absorbed him into their lives as their guru, their reliable and indispensable man.

*Chapter 10*

# The turning point

Gwendoline and Margaret bought only two substantial paintings in 1911, both by Millet. From the days of their first visits to the Louvre they were drawn to his dignified studies of country people. The son of a Normandy peasant, he always savoured the peace and silence of a stroll beside cultivated soil. He painted in Paris until he settled in Barbizon in 1849 at the age of thirty-five. It was a time when romantic and nostalgic ideas about rural life were changing. Millet began to show, not in any angry way, that what appeared idyllic had a subtext of work, backache and melancholy. Some of the critics preferred traditional and escapist rural scenes and disdained his realist peasant pictures as 'democratic painting'.

Gwendoline bought *The Sower*, a depiction of a farmer broadcasting seed, for £4,500. Margaret paid £2,400 for *The Peasant Family*, a touching study of a smallholder and his wife and child at their cottage door. The three wear sabots. The husband resting his hand on his spade and his wife clutching her yarn-spinning distaff suggest the medieval verse: 'When Adam delved and Eve span.' They stand facing us, intertwined, the wife's left hand through her husband's arm, his right hand gripping the child's shoulder. The child stands between them, their precious link, clutching their legs tightly with outstretched arms, so that they are three in one. The picture's impact is stronger for its unfinished roughness. Murray Urquhart advised the sisters to buy it.

In 1912, they spent nearly £19,000 on twenty-four pictures and sculptures. In January Gwendoline bought Whistler's *Nocturne: Blue and Gold, St Mark's, Venice* for £2,850, an atmospheric study of the domes of St Mark's looming in the gaslit gloaming against an indigo sky. Whistler was born in America, educated in Russia and spent much of his life in France and London, counting Monet and Renoir among his friends. Like Monet he relished the 'lovely London fogs'. In 1877 the irascible critic John Ruskin erupted when he saw the asking price for Whistler's *Nocturne in Black and Gold: the Falling Rocket*. 'I have seen and heard much of cockney impudence,' he protested, 'but never expected to hear a coxcomb ask two hundred guineas for flinging a pot of paint in the public's face.' Whistler

James Abbott McNeill Whistler 1834–1903          *Nocturne: Blue and Gold, St Mark's, Venice* 1880

A starry glow at dusk: white street lights make their modern mark on this impression of the Byzantine basilica

sued him for libel. Newspapermen and public crowded the court in London to relish the farce. Ruskin ruled that art should have a moral purpose. Whistler, a painter close to the French art world, retorted that it needed none, that art was for art's sake. A nocturne, he said, was an 'arrangement of line, form and colour … what it represents depends on who looks at it'.

He won a ludicrous farthing in damages and left the court penniless; but a hero in the minds of young artists. To earn some much-needed money he took a commission to make etchings in Venice. Captivated by the city, he stayed on for a year. The nocturne Gwendoline bought was one of three he painted there and he himself judged that it was perhaps the best of them. Whistler shows St Mark's from a viewpoint at the celebrated Florian's cafe. His method was to sit at a pavement table and stare at the scene, absorbing it, before going to his room to paint. Gwendoline and Margaret had memories of St Mark's on a starlit evening. Whistler's nocturne was irresistible.

Returning from Italy in May 1912 the sisters visited the Bernheim-Jeune gallery in the boulevard de la Madeleine in Paris. By this time they enjoyed a close relationship with the firm. Gaston and Josse Bernheim-Jeune were joint directors. Their cousin Emile was co-manager. The chief attraction for Gwendoline and Margaret was the first exhibition of twenty-nine of the pictures Monet painted in Venice in 1908. Monet was a latecomer to the city, sixty-eight when he travelled there. Although he feared that its popularity with so many artists might have made it a cliché he became a happy prisoner of its magical translucence and waterscape. He wished he had worked there when he was young and 'still full of daring'. His Venetian paintings delighted the sisters: this was the Venice they knew. They consulted Hugh Blaker. 'I will certainly keep my eyes open for anything good,' he wrote, 'and I am delighted that you think of getting some examples of the Impressionists of 1870. Very few English collectors except Hugh Lane have bought them at all, although much of their best work is in America. I expect you also know the work of Sisley, Pissarro and Renoir. These can still be got quite cheaply. Sisley, whose parents were English, was as good as any in my opinion, and Degas and Daumier are desirable, of course.'

With Hugh Blaker, Urquhart, Croal Thomson and others he gave lectures at the exhibition; and helped to write the catalogue. Perhaps we can detect Blaker's acidic pen in a catalogue note which praised Manet and slighted the arbiters of the Paris Salon. 'Manet, he said, 'was the senior member of the French impressionist group, from the first marked out by the apostles of the sham classicism and academic absurdities which dominated the salons of the period. Manet had the fighting spirit. Impressionism probably owes its existence to his genius.'

The exhibition was a landmark and provoked much discussion about the state of art in Wales. Some of this reflected deep dismay. It seemed that not much had changed in the thirty years since Lord Bute had complained that Cardiff's buoyant prosperity had been 'but slightly accompanied by any encouragement of art'. The Davies collection was a work in progress and the exhibition the first showing in Wales of such a rich assembly of modern French art. Few were aware that such a collection existed.

A kiss for ever: Rodin's sculpture was one of the attractions of the pioneering and popular exhibition in Cardiff city hall in 1913, a show mostly of works from the sisters' growing collection

The sisters funded the entire exhibition, including the furnishings and catalogue, and did so anonymously. They and other owners were described as 'a few friends interested in Art'. They had needed no urging to display their paintings. They believed it was their social responsibility to share their art with the public.

'It is a privilege,' said the Western Mail, 'for the art-loving public to have the opportunity of seeing paintings which only the wealthy can afford. In this instance the owners' names are not disclosed: the glory of public mention is reserved to the artists! We only know that the owners are all resident in Wales. Many people will be surprised to find that treasures so valuable and so representative of the best efforts of modern masters are possessed in such profusion in Wales. If such opportunities could be provided more frequently an impetus would be given to the art movement which is always striving to find expression.'

Joseph Staniforth, who was for thirty years the Western Mail's caricaturist and art critic, used some of his review to attack the city council's 'porcine indifference' to paintings and its failure to understand that the encouragement of art could help to create wealth. He commended the museum for providing an art education for the public. 'When the art history of Wales is contrasted with, say, that of Scotland, and Welsh appreciation of the fine arts considered with that of her Scottish sister, it can only be lamented that a nation so rich and so eager for education generally is yet so lagging in the culture of the fine arts. Few cities are doing less than Cardiff to educate its population in the love of art. A serious charge to bring against the capital of Wales. There is no earthly reason why Welshmen should not equal Scotsmen in the cultivation of art. Their brain capacity is in no way inferior.'

Staniforth admired the Turners and the Whistler nocturnes. He thought Meissonier's *Innocents and Card Sharpers* was a jewel. He liked Monet's *Charing Cross Bridge* but his overall view of the Impressionists was that 'in general, the artist endeavours to conceal by a plenitude of gaudy colours his ignorance of the knowledge necessary to his craft'. He thought Manet's picture of the church of Saint Pierre at Petit-Montrouge 'ought

Jean-Louis-Ernest Meissonier 1815-1891 *Innocents and Card Sharpers* 1861

Master of the detailed exquisite, Meissonier was Manet's commander in the siege of Paris. The two did not see eye to eye on the purpose of art

never to be framed let alone exhibited'. Corot was not an Impressionist but Staniforth dismissed his landscapes as 'dirty' and 'colourless'. Another critic growled that the feeling for fine art in Wales was almost non-existent. 'Why talk of revivals of art when the whole fabric of the district is built upon such horrors (artistically speaking) as the Rhondda?'

The larger-than-life bronze edition of Rodin's *The Kiss*, bought by Gwendoline from the Georges Petit Gallery in Paris in September 1912, held centre stage at the exhibition. Rodin originally intended *The Kiss* to be part of his formidable work *The Gates of Hell*, commissioned by

*The Kiss.* Pride of place, famous and admired

the French government in 1880 to embellish a proposed new institution, the School of Decorative Arts. Rodin drew his theme from The Inferno, the first part of The Divine Comedy by the medieval Italian poet Dante Alighieri. He was also inspired by Michelangelo's Last Judgment on the wall behind the altar in the Sistine Chapel in the Vatican. His *Gates of Hell* took the form of massive double doors, eighteen feet high and twelve feet wide. On these he filled panels with scores of writhing, restless and uninhibited figures in low relief, 186 of them in all. He worked on the gates for thirty-seven years, until he died, discarding figures and replacing them with others so that it remained unfinished. The School of Decorative Arts was never built.

For *The Kiss* itself, the sensuous drama of entwined lovers, Rodin turned to Dante's story of Paolo and Francesca in The Inferno. Paolo's left hand holds the book of Arthurian legends in which he and Francesca have just read the arousing tale of Lancelot and Guinevere. Francesca places her left arm around Paolo's neck and draws him towards her. Rodin depicts their consuming passion in the moments before Francesca's husband discovers and murders them.

The sculpture's permanent home is the national museum in Cardiff. People still express surprise that Gwendoline bought it at all; but, like her sister, she had steeped herself in the study of classical sculpture and painting in the galleries of Florence and elsewhere. For all her reserve she had firm opinions and acquired the work because she had the confidence to do so. Its beauty moved her; and Rodin was, after all, the greatest French sculptor of the nineteenth century. The exhibition catalogue said that *The Kiss* was 'one of the most awe-inspiring works of art of modern times', and that is exactly what Gwendoline thought. Margaret, as we have seen, studied Rodin during her art course in Dresden and recorded her tutor's judgment that *The Kiss* was 'the most beautiful' of his works. At Lewes in 1913 the nervous authorities shrouded and railed off a marble version of *The Kiss*, fearing that an embrace so intense and candid might frighten the horses. In Cardiff Blaker and Co assumed that Wales would take beauty in its stride. And so it did. No one fainted. Velvet

banquettes close to the sculpture facilitated contemplation. Staniforth, in his Western Mail review thought simply that *The Kiss* was 'delightful in its tenderness'.

The exhibition was successful. It ran for nearly eight weeks and attracted about 500 people daily, more than 26,000 in all. For the majority of them it was their first view of the brilliance of the controversial Impressionists. An art magazine judged the exhibition one of the most important ever staged outside London. The flamboyant Hugh Blaker had no doubts as he reached for his diary. 'A most stupendous show,' he exulted, as if buffing his fingernails on his lapel, 'which should be a milestone in Welsh artistic

Eugène Carrière 1849-1906                                              *Maternity* 1890

Carrière's intimate paintings so moved Gwendoline that she bought six of his works

development.' Although his friend Murray Urquhart had also played a key role, Blaker added: 'I felt a little tingle of delight at the opening – that I had the privilege to get most of it together.' After Cardiff the exhibition went to the Holburne in Bath for two months. Blaker, meanwhile, wrote a chortling note in his diary. 'I have put the Bath Society on its artistic feet,' he declared. 'They knew not of Millet, Monet, Renoir, Legros, Sickert and many others until I introduced them, and then they swore at 'em – at first!'

<p style="text-align:center">※</p>

In April 1913, just after the Cardiff exhibition, Gwendoline bought *La Parisienne* and put it on show with the other paintings at the Holburne. It was quite a coup. A few weeks later, in May, she bought two oils by Eugène Carrière from Bernheim-Jeune. These were *The Footbath* and *Maternity (Suffering)*, evocations of motherhood, intimate, mistily painted, faintly coloured and delicately delineated. Carrière found all he needed for his art among his family and friends. For his studies of motherhood he had his wife and children. Gwendoline engaged emotionally with his portrayals of peace and maternal love, and bought six of his works between 1913 and 1920.

During 1913 the sisters' collection reached a total of ninety-two paintings and sculptures. They bought eighteen works, including a Rodin marble, *The Clouds*, for £3,045, and a bronze of *Saint John, Preaching*, for £2,000. They also purchased four paintings by Monet. Margaret paid £1,600 for his *Charing Cross Bridge*, painted in 1902. Monet first travelled to London in 1871 to escape the war in France, but had a bleak time of it, being pessimistic and short of cash. After 1899 he returned to paint his series of London views, studies of buildings and bridges along the Thames, including the Houses of Parliament and Waterloo Bridge.

He liked London's riverscape, particularly in winter, insisting that he enjoyed a good thick fog because it endowed the city with a 'magnificent breadth'. 'Without its fog,' he explained, 'London would not be beautiful.'

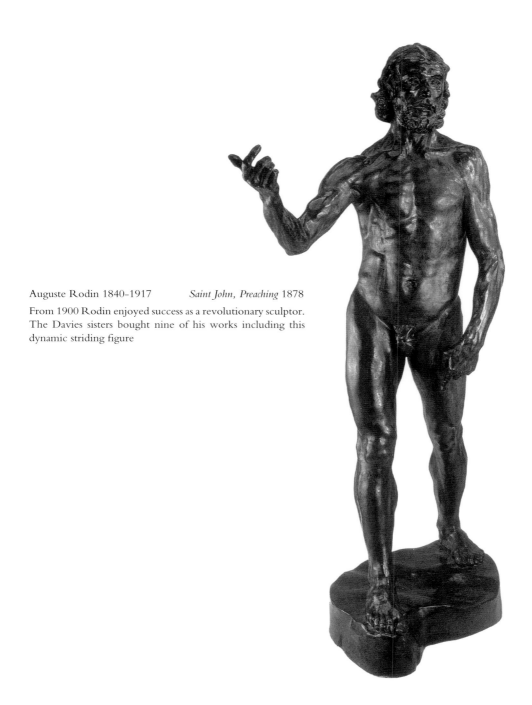

Auguste Rodin 1840-1917          *Saint John, Preaching* 1878

From 1900 Rodin enjoyed success as a revolutionary sculptor. The Davies sisters bought nine of his works including this dynamic striding figure

His fogs were never grey for he always gave them a subtle colour. London's weather was his constant challenge and the work funded his liking for the pampering he received at good hotels. He painted in a room at the Savoy hotel where his balcony commanded a satisfying view of the river. His output included thirty-five pictures of Charing Cross Bridge. Margaret bought her version of it from the French Gallery. Its previous owner was the Duke of Marlborough. In July 1913 she also acquired Monet's painting of the fifteenth-century Palazzo Dario on the southern side of the Grand Canal in Venice, one of the thirty-seven paintings he began in his Venetian foray in 1908. It was bought from Durand-Ruel for £1,310. At Bernheim-Jeune in July Gwendoline paid £3,370 for three perfect water lily pictures, *Nymphéas 1905, 1906* and *1908*, the years in which Monet had painted them.

Monet's love of lilies led him to create a water garden in a meadow and pond near his home in Giverny, forty-five miles north-west of Paris. He started excavating and landscaping it in 1893. What he called 'the magic of my pond' grew into the passion of his later years. In his request for planning sanction he said the lily garden would be a motif for his art. 'It dawned on me how wonderful my pond was and I reached for my palette.' He began his phenomenal lily pictures in 1895. On the curve of the garden's Japanese bridge, among the bamboo and Japanese flowers, he set up several easels before dawn and began to paint the lilies and their reflections in the waxing and waning light. His fastidious gardeners, meanwhile, kept the pond water pristine and tended the lilies with the devotion of nurses, even washing specks of dust from the petals. Monet wrote ruefully that his liliaceous paintings were 'beyond the powers of an old man', but by then he was a prisoner obsessed by water and reflection. Over the years he painted 300 pictures of lilies. Some were almost abstracts. Durand-Ruel staged a celebratory exhibition of forty-eight of them in 1909. Monet basked in admiration. He had become a star. A critic wrote to him: 'I admire you most of all among today's French artists.'

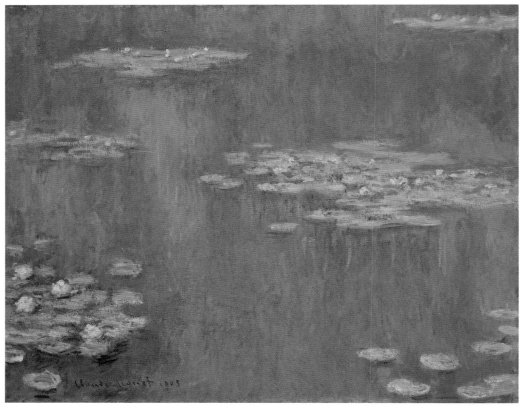

Monet                                                                                   *Waterlilies 1905*

Lilies and their valets: cosseted flowers of Monet's magnificent obsession

Coal production in Wales reached a peak in 1913. On the morning of 14 October the human cost of coal was underlined by an explosion at Senghenydd colliery, owned by the Universal company, ten miles from Cardiff. It killed 439 men and boys, widowed more than 200 women and devastated the village community. It was the worst mining disaster in British history. The Davieses sent £500 to the disaster fund.

Tom Jones had moved to a large house at Barry in a district known jokily as Swelldom. Always willing to cram every minute he taught Workers' Educational Association classes. In January 1914 he was a founder of The Welsh Outlook, a monthly illustrated magazine of debate and opinion, published under the motto 'Where there is no vision the people perish.' David Davies financed it. Tom Jones was its editor. One of its early contributors was Winifred Coombe Tennant of Neath, a social reformer and supporter of young painters, who became a friend of Tom Jones. The journal broke new ground in Welsh life in its secular social and political

Daumier

A figure at the republican barricades in Paris, 1848

*Head of a Man* 1850s

Daumier                                                              *The Watering Place* 1850s
The horse shies to dramatic effect in a scene by the Seine, Margaret's purchase in 1914

discourse. It reflected Tom Jones's progressive support of art. The first edition carried a reproduction of Millet's painting *Going to Work*.

The first six months of 1914 were the last chapter of the Edwardian era before Europe unravelled. Gwendoline and Margaret pursued their fondness for Daumier's work and bought three of his oils. They liked

his compassionate eye, his all-human-life-is-there approach to pictures of ordinary people, his little fanfares for the common man. In 1914 Gwendoline bought two, *Head of a Man* and *The Heavy Burden*. The man is moving, turning his head to the right. The burden is the laundry carried by a Seine washerwoman wearing a headscarf, hurrying against the wind with a little girl clinging to her, trying to keep up. Margaret bought Daumier's *The Watering Place*, in which a white horse approaching the Seine to drink is spooked by a dog barking in the gloom. It seems like a frame from an illustrated action story. In March 1914 Margaret also purchased a small Renoir, *Young Girl in Blue*, a charming sketch in oil. Gwendoline acquired two more of Carrière's studies of motherhood, *Maternity* and *Mother and Child*. She paid £2,800 for the Rodin marble *The Earth and the Moon*, one of the works from his *Gates of Hell*. Two delicate figures emerge from the block of marble as if the sculptor had discovered spirits there and chiselled them free.

# A watch shining in the sun

erman forces smashed their way into Belgium in the early days of August 1914. People in their thousands fled before the guns. Many headed for the Channel ports. Around 110,000 refugees found sanctuary in Britain. The Davieses of Llandinam, David, Gwendoline and Margaret, acted swiftly to finance a daring rescue of stranded Belgian artists, sculptors, musicians, poets and their families. Their pimpernels were the resourceful Thomas Jones and David's secretary William Burdon Evans, assisted by Dr Fabrice Polderman, a Flemish scholar who had been teaching in Cardiff. In September the three of them crossed to Ostend and travelled for two weeks to Zeebrugge, Knokke, Bruges, Ghent and Nieuport. They gathered ninety-one people. Burdon Evans looked them over and judged them to be 'refugees of the better class'. On 3 October, with the Germans closing in and the remnants of free Belgium shrinking rapidly, the entire party escaped across the Channel on the last vessel but one to leave Ostend.

A few days later Gwendoline and Margaret welcomed the bewildered Belgians at the Gwalia hotel in London and took them from Paddington to Aberystwyth. A crowd of hospitable people waited at the station to offer homes. The Davieses themselves housed and supported seven refugee families, around thirty people, for the duration of the war. A local newspaper described the Davieses simply as 'a well-known benefactor'. Gwendoline remarked to her stepmother: 'There you see, Mother, money

is of some use after all.' Many people in Wales offered accommodation and in 1915 the Western Mail published a war-news column in Flemish. The Davieses installed the distinguished sculptor George Minne in the new garden village housing at Llanidloes.

Before the war Gwendoline, Margaret and Tom Jones had discussed the idea of importing foreign talent into the University of Wales to stimulate arts, crafts and music. They thought that an influx of refugee painters and musicians could form the inspirational creative pool they had talked of. Belgium's long artistic history included a tradition of painters' colonies in the countryside, a lively avant-garde and a version of Impressionism.

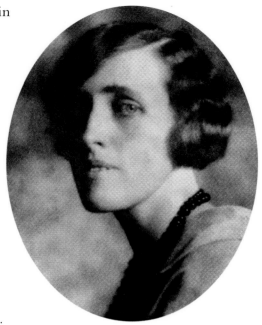

Margaret: her journals reveal her enjoyment of art, study, foreign travel and a private life

In November The Welsh Outlook wrote: 'The study of painting and sculpture is in a deplorably backward condition in Wales. Shall we take full and immediate advantage of this brilliant group?'

In the event there was little creative osmosis. The Belgians were naturally grateful for refuge but they missed their native Flanders. Valerius de Saedeleer, who spent the war near Aberystwyth, painted landscapes in Cardiganshire but found little affinity with the mountains. 'We have no right to complain,' he said. 'We have been so lucky to be together. I have been able to work and give the children their education. It is a lovely area, the people are kind, nevertheless I am yearning for Belgium.' George Minne, who was with his wife and six children, lacked the materials he needed for his sculpting and turned to charcoal drawings. He drew murals on his walls in Llanidloes dedicated to 'friends known and unknown in

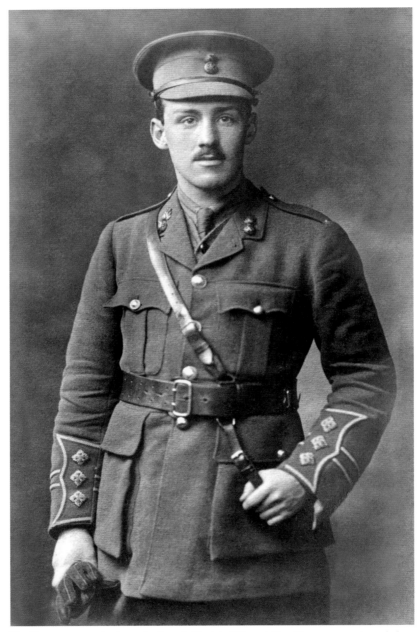

'I will not turn my back on the boys.' Captain Edward Lloyd Jones, a cousin and close friend of Gwendoline and Margaret, fought and died at Gallipoli

the lovely land of Wales'. Like his fellow-countrymen he experienced the ache of exile among hills that seemed wild and alien. The refugees had sanctuary but it was not easy for them to live on charity. Gwendoline was sympathetic.

David Davies was thirty-four when the war broke out. In November 1914 he set to work with typical vigour to raise the 14th battalion of the Royal Welch Fusiliers in north Wales. The story goes that during his recruiting drive he was walking with a fellow officer at Deganwy on the coast when a soldier in uniform passed by without saluting. Davies called him back. 'Hey, do you know who I am?' 'No,' said the soldier. 'Well, I'm Colonel David Davies of the 14th Royal Welch Fusiliers.' 'Well,' said the small recruit, 'you've got a bloody good job, you stick to it.' David Davies always laughed loudly whenever he repeated this tale. In 1915 he led his battalion to France and the western front.

His cousin Edward Lloyd Jones was commissioned as a captain in the 7th battalion of the Royal Welch Fusiliers. Edward's younger brother Ivor also joined the RWF. Edward had travelled with Gwendoline and Margaret before the war during their long cultural holidays in Greece, Italy, Germany and elsewhere. He was good humoured and entertaining and undoubtedly brightened the sisters' lives. They knew him by his family nickname of Dolly. He was six years Gwendoline's junior. He had a serious and thoughtful side to his lightheartedness. Gwendoline remembered a walk during which she talked to him of the pleasure she took in riding and hunting; and he persuaded her there were 'better things in life than chasing a small frightened animal' over the hills.

In the summer of 1915 Edward had a dream in which he died in battle. He spoke about it to his cousin George Maitland Lloyd Davies, who was taking a difficult wartime road as a pacifist and conscientious objector. Edward told George that although he felt the war was 'altogether wrong, I will not turn my back on the boys'. George explained his commitment to the pacifist cause and Edward replied: 'Even if no one else understands

you, I shall.' Later he wrote encouragingly to George: 'Does any honest Christian believe that the problems of life can be decided by force of arms? For pity's sake, keep one clear light shining brightly in this awful night.'

By then Edward and Ivor had embarked with the expeditionary force bound for the Dardanelles. Their cousin Stanley Davies, a barrister, was with them. On the eve of their departure Gwendoline and Margaret made Edward a present of a watch. He gave Gwendoline a brooch modelled on the RWF badge. 'It may serve to recall many happy memories,' he wrote to her before his ship sailed. 'I fear I am indifferent to the future. My love to everyone and especially to yourself.'

On 15 July he wrote to his mother in Llandinam: 'Our destiny is the Dardanelles. We are the last of the Crusaders, adventurous spirits called forth to release the East from the thraldom of the Turk.' In another letter he said: 'For good or ill we are pawns in the mighty game of war. God alone knows the value to place on our sacrifice. The spirit of adventure misleads our activities. Is our Crusade utterly devoid of virtue? Even the church seems divided. Some regard the conflict of today as the last of wars. Such was the cry a hundred years ago and such will be the cry a hundred years hence. These are some of my thoughts as I gaze on the eternal ocean.'

He wrote to Gwendoline on 6 August: 'We are now in waters which are very familiar to you. My mind reverts continually to our voyage of four years ago: think of it, on that occasion our travelling companions were two German officers and a Turk! How quickly things have changed and how wicked it all is. Friends of yesterday are enemies today. I cannot describe our route for reasons you will understand. We are constantly passing islands well known in Classic history. Do you remember the boat we travelled with to Athens? Well, that vessel was a palace to this one. My best love, from your affectionate Dolly PS There is no rest in Gallipoli. Everywhere is within range of the guns.'

Three days later he scribbled a note to his mother from Suvla Bay, the expedition's bloody landing place. 'Here we are in the thick of it, or about to be. I am afraid this is a rather mournful epistle, but it is well to realise the worst possibilities.'

A telegram in the family archive is marked OHMS Shrewsbury: 'Regret to inform you Captain Edward Wynne Lloyd Jones was killed in action August 10. Lord Kitchener expresses his sympathy.'

Edward was twenty-seven. His cousin Stanley Davies wrote to Edward's mother from Suvla Bay on 11 August: 'My dear, dear Auntie – We had a most terrible battle from 4 o'clock in the morning until 7.30 at night. On my way to the firing line I found quite by chance our poor dear Dolly lying in peace. His right arm was folded over his breast and on his left wrist was the watch Daisy and Gwen had given him. I do not think he suffered. God bless you all, Stan.'

In a letter to Gwendoline Stanley described what he saw on the battlefield. 'My dear G, He lay with his face to the sky, his left arm stretched out and your little watch glistening on his wrist. I am telling you all these details because I think they will mean something to you as they did to me. Stanley Davies.'

Edward was buried by a fig tree. Stanley went to the grave and marked it with a wooden cross on which he wrote some words in Welsh 'from your friends in your dear home'. Stanley added: 'I knelt on the grave as it was getting dark and read the resurrection chapter from Corinthians. It was read hurriedly as shells were going over and a lot of rifle bullets passing.'

A soldier from Llandinam sent Gwendoline a description of the action. 'Dear Miss Davies, I thank you very much for the parcel. I don't think there was a fellow that did flinch at all, you should have seen how the Captain led us there was no flinching about him and he was cheering the fellows all the while. The Turks was up on top of the hill shelling us and there was shrapnel flying everywhere and the last I saw of him was when we got in the first charge he was about 50 yards in front of us going ahead we could not follow. I don't think there was a braver soldier on the field but I know he came out of the charge all right because he was shot behind the firing line and I think a sniper must have had him as they were all over the place there up trees. We miss him awfully in A Coy and if he was here we should be able to have a sermon on a Sunday and a few hymns. But

that is how it is in warfare. I have no more news at present only I thank you ever so much for the parcel. This from Dan Jones.'

On 27 August Ivor wrote to his family from the British Expeditionary Force base near Gallipoli: 'I expect that by now you have heard all about his sad death. I miss him terribly. We had a good old dose of it up there, I can tell you. Probably by now our casualty lists are out so you have seen what we have lost. How I escaped, God knows. First of all we got ordinary explosive shell, then we tasted shrapnel, then spent rifle bullets were dropping around in the sand kicking up the dust, there was plenty of work for the RAMC men there. Dr Davies our MO was splendid and saved many a life: some of the wounds were terrible. Snipers were doing a lot of damage. Luckily most of them were bad shots or else your humble servant would not be writing this letter. Well, cheer-oh now!'

In October Gwendoline and Margaret donated £1,500 each to The Times Sick and Wounded Fund. They specified that it should contribute to the purchase of motor boats to ferry soldiers wounded in the Dardanelles to hospital ships offshore.

Ivor was killed in the fighting in Palestine in March 1917, aged twenty-two, and buried at Gaza. For the rest of their lives Gwendoline and Margaret treasured a small leather wallet containing photographs of their cousins in their uniforms.

Gwendoline was deeply affected by Edward's death. Twenty years later she wrote to Tom Jones about him. 'Often during the war I used to climb the hill at home all alone, early in the morning and read Dolly's last letter to me – the one he left with his cousin to be given to me only if he were killed. We had been great friends, he and I, ever since his Cambridge days when perhaps I had been able to help him "keep straight". He always told me of his difficulties and temptations, and of the College don who seemed determined to shatter his faith in "the things which are not seen" – I had always looked upon him as a younger brother – and then this letter, like

a voice from the other side telling me he had been caring for me all the time, though he knew it was quite impossible – It came as a shock to me and I was at once haunted by the thought – was that the reason he had insisted on going out to Gallipoli (with his leg in such a condition)? Had the friendship which had been so rich, so helpful to both of us been all a mistake? Could one never help a friend with something other than "all or nothing."'

# Our friend the poilu

fter Edward's death Gwendoline and Margaret resolved to go to the war to help soldiers. Charity work at home was a solace but not enough. They loved France and spoke French. They were single, free, in their thirties and had their own money. They were also courageous. Whatever the danger and hardship in France they longed to serve there. Some adventurous women had already made their way to France in 1914 and 1915. The First Aid Nursing Yeomanry organized those who were medically qualified and able to drive. Similarly, there were Voluntary Aid Detachments of unpaid assistant nurses, ambulance drivers and cooks. The war created its own imperatives: in May 1915 the government had no choice but to call on women to work in munitions factories. In 1916 conscription drew thousands of men into the forces; and women of all classes flocked to take jobs in offices, factories and transport. Others trained as nurses and auxiliaries.

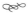

Gwendoline and Margaret bought no pictures in 1915 but resumed their collecting in the following year. A critic commented in The Welsh Outlook that it was extraordinary that Augustus John's painting was 'practically unknown in the land of his birth'. Gwendoline agreed and determined that it should have a better showing in Wales. In April 1916

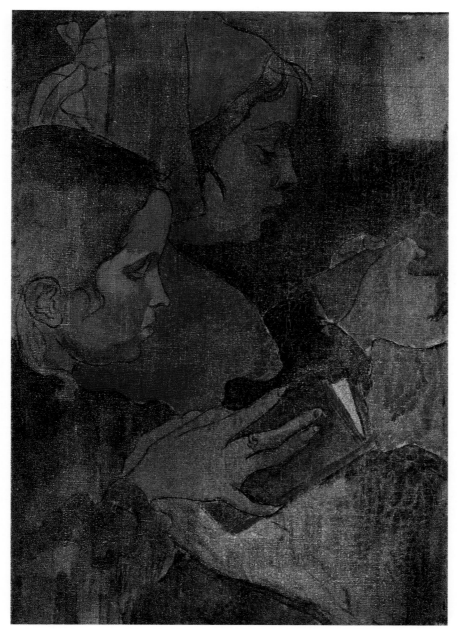

Armand Seguin 1869-1903         *Breton Peasant Women at Mass* 1890s

Seguin joined the group of artists at Pont-Aven in Brittany

she bought ten of his oils and a drawing for £2,350, almost half the pictures in an exhibition of his work at the Chenil gallery in Chelsea. The restless bohemian was ever controversial. Many admired his striking portrait of Lloyd George painted early in 1916. Lloyd George did not. John himself admitted it was unconventional but grumbled that Lloyd George was a fidgety sitter: a 'hot-arse who can't sit still and be patient'. For his part Lloyd George's feelings about the artist led him to persuade Frances Stevenson, his mistress, that she should neither sit to him for a portrait nor attend any of his parties. Hugh Blaker met John in a bar in Chelsea in 1916. 'Although thirty-eight,' he reported, 'he looks fifty. He has lived.' The artist longed to go the front. The newspaper owner Lord Beaverbrook pulled strings and found him a place as an honorary major in the Canadian forces in 1917. John worked on the western front for five months and painted several excellent portraits of soldiers. He also started a mural thirty-six feet long, but never finished it. After an incident in March 1918 in which he punched an officer, Beaverbrook hurried him home and averted a court martial.

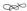

Gwendoline purchased a Rodin bronze, *Eve*, for £1,500 in 1916. She also bought *Breton Peasant Women at Mass*, a picture of two women with their prayer books, attributed to Paul Gauguin and exhibited as such at the Victoria art gallery in Bath from 1918-20. Later scholarship, in 1960, showed it to be the work of Armand Seguin, a pupil of Gauguin whose oils reflect Gauguin's style.

In June 1916 Gwendoline and Margaret attended the opening of the first pithead baths in Wales at the Ocean Coal Company's Deep Navigation colliery in Treharris. This was a milestone in mining welfare. In the long run such humane facilities ended a wretched tradition. In common with colliery workers throughout Britain a quarter of a million miners in Wales tramped home each day, black-faced, soaked and filthy, to wash in a fireside tub. The practice made slaves of wives and mothers

Herbert Asquith and wanted to know how the political wind was blowing.

David Davies worked enthusiastically to enlist Liberal support for his boss. On 7 December Lloyd George became prime minister.

His cabinet secretariat had a pronounced Welsh identity. A number of the staff, including the assistant secretary, Tom Jones, spoke Welsh. There was a Welsh cook, too. The prime minister's personal secretariat was known as 'the garden suburb' and also had a Welsh accent. David Davies was part of it and from June 1916 to June 1917 was close to the centre of power and the witness of crisis and dramatic events: the Somme, Verdun, French army mutinies, submarine warfare, the American declaration of war against Germany. In 1917 Lloyd George sent

Like Squire Headlong in Thomas Love Peacock's story, David Davies lived at high speed. He had 'a life of furious beneficence'. He helped to raise the 14th battalion of the Royal Welch Fusiliers and led his men on the western front

Lord Milner at the head of a fifty-strong commission to assess the turmoil in pre-revolutionary Russia. Davies was one of the team and went into the streets to assess the mood of ordinary people. He saw that Tsarist rule would soon collapse and revolution would follow.

Meanwhile he relished his mission as Lloyd George's eyes and ears. He signed his frequent reports with the jaunty signature Dafydd bob man, meaning David Everywhere. But he began to overreach himself. The prime minister was a politician of guile as well as ruthlessness. David Davies disliked deviousness. As an impatient go-getter without much sensitivity he believed his boss should be frank and blunt rather than wily. The prime minister began to view Dafydd bob man as an irritating source of unsolicited criticism and a self-appointed conscience. Feeling himself

licensed as the ever-candid friend Davies protested about the allies' failure to support Serbia. He also grumbled about an increase in beer production. His views of politicians and senior soldiers grew increasingly opinionated and, where he thought it necessary, he wrote critically of Lloyd George himself. In April 1917 the furious prime minister barked a 'Go to hell' warning at him. The fateful moment came a few weeks later when Lloyd George appointed Lord Northcliffe, rather than Balfour, to lead a mission to the United States. David Davies could not contain his critical opinion. His letter to his boss on 23 June showed no restraint.

> My dear Chief,
> I have seen various people of all colours this week and the impression left on my mind is that the Govnt stock, and yours in particular, is tumbling down. The Reform is seething with discontent, and even the Tories are beginning to ask questions.
>
> It's no good, my dear Chief, you can't go on fooling the people indefinitely. They take you at your words – if you play them false they will send you to Coventry with Winston. They thought you were a man of his word, who would not tolerate delay, who would make a clean sweep of incompetents – ministers or soldiers. They thought you were out to win the war for the vindication of the principles we are fighting for. Making the fullest allowances for all the tremendous difficulties which have beset your path, have you employed the best means of fulfilling these expectations – have you run the straight course? Have you set your teeth and done what was obviously the right thing – regardless of other considerations? This was the one course which could bring you success and victory in the long run. The moral factor is the only one which counts in the end, and that is why so many brilliant people come to grief. You can call me anything you like my dear Chief – it's damned unpleasant – but it is the truth.
> Yrs.
> Dafydd bob man

This was definitely the last straw; and in his response Lloyd George played the scorpion.

> 24 June 1917
> My dear Davies,
> I regret having to tell you that there is a concerted attack to be made upon me for what is called 'sheltering' in a soft job a young officer of military age and fitness. I am told that the attack is associated with the efforts made to reinforce the Army by re-examining the rejects. It is urged that it is a scandal to force men of doubtful fitness into the fighting line when others whose physical efficiency is beyond question are shirking under powerful protection. I hear that Welsh parents – North and South – are highly indignant and do not scruple to suggest that your wealth is your shield. I know that you are not responsible, but they blame me, and as I know that you are anxious not to add to my difficulties in the terrible task entrusted to me, I am sure you will agree that I am taking the straight course intimating to the Committee set up to re-examine men in the public service that in my judgement you can render better service to your country as a soldier than in your present capacity.
>
> I have put this quite bluntly to you, as I have always found that you preferred plain speaking, however disagreeable. My only apology is for having withheld from you so long rumours which were detrimental to your patriotism and courage, both of which I know to be beyond reproach.
> Ever sincerely,
> D Ll G

This was a harsh letter. There was no evidence of any truth in Lloyd George's allegations. The split could not be repaired. David Davies hoped to return to active service but this wish was thwarted. Perhaps some senior officers felt there was no profit in accommodating such a troublesome critic. Perhaps Lloyd George himself did not want him to return to the front. Davies therefore made his way to the Montgomeryshire hills, to

his three packs of hounds and his duties as an MP. His wife Amy was increasingly unwell. His son David, called by his second name of Michael, was a year old. David Davies put his mind to the future, to international affairs and the abiding threats to peace. He began to construct a grand new campaign that would consume his energies for the rest of his life.

His friend Tom Jones, who witnessed his fall, knew from daily experience how hard and unforgiving Lloyd George could be. From his place in the cabinet secretariat he saw the prime minister at close quarters almost every day. Jones was then forty-six, well-informed, socially warm and a man with many contacts. As he explained later, he had 'direct access to the prime minister. Our common Welsh background and use of Welsh made intimate relations with Lloyd George easy and I was welcomed at the famous breakfasts and used on confidential errands to and from his colleagues'. Tom Jones defined his own role as that of 'a fluid person moving among people who mattered and keeping the PM on the right path so far as possible'. He had an enthralling view of the conduct of the war and joined the inner ring of civil servants known as 'the family' who exchanged information at weekly dinners. Quite soon all Whitehall knew him simply as TJ. Lloyd George drew on his wisdom and discretion.

※

In April 1917 Gwendoline went by train from Troyes to Paris and to the Bernheim family gallery. She bought two pictures which the gallery stored for her. One was Daumier's *Lunch in the Country*, of 1868, an oil vigorous, masterly and entertaining, a study of three men and a dog at a table. She paid £1,290 for it. The other was Carrière's *The Tin Mug*, for £1,650, another of the studies of maternal love of which she was fond.

She returned to the gallery in December and purchased four more pictures, a Renoir, a Manet, a Monet and a Pierre Puvis de Chavannes. She paid £2,000 for Renoir's *Conversation*, a small and sensual study of a couple sitting in the dappled shade of an apple tree; and, indeed, the girl's cheeks have an apple glow. Renoir painted it in 1912 when he was

Gwendoline continued her support for Augustus John and paid £550 for the striking portrait he painted in 1919 of the poet W H Davies, author of The Autobiography of a Super-Tramp. Davies's head is crowned by the distinctive topiary of his quiff, his smiling face tilted upwards as he looks dreamily into the middle distance. Poet and painter spoke little during the six days they were together. Davies recalled John's 'terrible silence' as he worked at his easel. Since the artist had forsworn drink for the duration of his work on the portrait he was perhaps gritting his teeth.

The poet disliked the painting. Gwendoline, however, fell for it as soon as she saw a photograph. 'It is a wonderful thing,' she wrote to Tom Jones, 'I hear it is for sale at quite a reasonable price and I am hoping to get it for Cardiff this time! I don't think they would refuse.'

The reference to Cardiff was intended to raise a rueful smile on Tom Jones's face, a swipe at the college in Aberystwyth. A few weeks earlier, in November 1919, he had failed in his ambition to become principal of Aberystwyth college. He had longed for a frontline role in higher education. His jealous enemies, however, found fault with his religious agnosticism and preferred their own narrow horizon. They also disliked his association with David Davies who was himself characterized by some as a rich schemer who wanted to take over the people's college. Tom Jones's supporters included Lloyd George but still could not swing the vote. So devious and vitriolic was the campaign against TJ that his biographer remarked that Machiavelli would not have felt out of place in Wales. TJ's disappointment was profound. As his friends, the Davieses were similarly dismayed. They were loyal and generous supporters of the university as they were of the national library and the museum. David Davies was president of the college at Aberystwyth from 1926 to 1944.

❧

Vincent van Gogh 1853–1890                                   *Rain-Auvers* 1890

In July 1890 van Gogh was utterly absorbed in the canvases he painted at Auvers. He shot himself soon after completing this painting. The crows seem like mourners

In 1920 the sisters spent more than £25,000 on thirty-three works of art. A number of these were significant additions to the collection. For £1,400 Gwendoline bought one of Manet's studies of boats at Argenteuil, a village ten miles north of Paris where the Oise joined the Seine. A weekend resort for the Paris middle class it was renowned for asparagus and artists, regattas and restaurants, graceful sailing boats and a tree-lined riverbank. Far from being sleepy it had the factories and chimneys of modern industry. Artists came to paint sociably in twos and threes, to gossip and sketch the yachts. Monet had a house here and a little studio-boat. He and Renoir sat at their easels, genial friends painting the same scene, two beards in the sunshine.

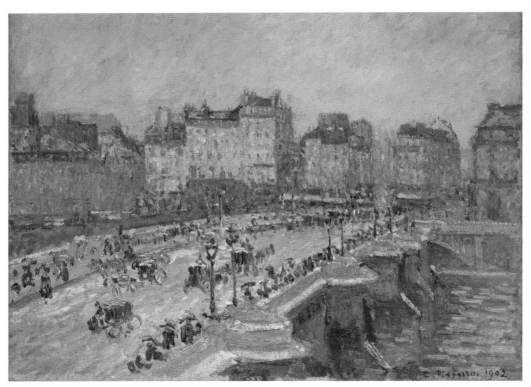

Camille Pissarro 1831-1903                                   *Pont Neuf, Snow Effect* 1902

The Pont Neuf was a theatre of Paris hurry. The hard-working Pissarro was in his seventies when he painted this scene from a flat overlooking the bridge. Margaret bought the painting in 1920

Gwendoline's purchases in 1920 included Vincent van Gogh's powerful *Rain-Auvers*, for which she paid £2,020 at Bernheim-Jeune. It was the only van Gogh she bought, one of the first of his paintings to enter a British collection. It reveals the influence of the Japanese prints he studied for five years. The landscape is cast in sections of colour. Wheat fields and sky, ragged crows and twists of poplar are seen through rain slanting like arrows at Agincourt. Van Gogh had noted how Utagawa Hiroshige had rendered a shower in this way in one of his prints, *Ohashi Bridge in the Rain*. *Rain-Auvers* was one of the thirteen pictures van Gogh painted in July 1890 at Auvers-sur-Oise, twenty miles north of Paris. Despair filled his life that summer. He wrote to his brother Theo telling him of his sadness and 'extreme solitude' as he worked on his landscapes beneath 'troubled skies'. A few weeks after he completed *Rain-Auvers* he killed himself.

In 1920, at Hugh Blaker's suggestion, Margaret bought two oils and four drawings by Vlaminck. She also purchased a newly-completed portrait of Madame Zborowska, the Paris art dealer's Polish wife, by André Derain. She also bought two oils and six drawings by Pissarro. One of these oils, *Pont Neuf, Snow Effect*, was the only Impressionist work in the sisters' collection depicting the everyday bustle of Paris life. Horse-cab and human traffic crowd the majestic bridge as snow falls. Dogged pedestrians lean forward under their umbrellas, the simplest of Impressionist dabs, abrupt exclamation marks of movement on the canvas.

Gwendoline acquired four more pictures by Cézanne in March 1920. Three were watercolours. The fourth and most notable was *Still Life with Teapot*, an entrancing oil for which she paid £2,000. A dish of fruit, a knife and a white teapot form a thoughtful and provocative arrangement on a rumpled rug which seems to pose as a Provençal landscape.

This and the Cézanne oils she bought in 1918 - *The François Zola Dam* and *Provençal Landscape* - underlined Gwendoline's standing as a collector of independent mind. In art, at least, it did not go against the grain with her to be intellectually adventurous and to embrace new ideas. In the Courtauld Collection catalogue in 1954 the turbulent art historian Douglas Cooper

Cézanne
Rugged hills in a tabletop landscape

*Still Life with Teapot* 1899

wrote that 'The principal event of the decade 1910–1920 was the appearance of a successor to Hugh Lane in the person of Gwen Davies.' She entered the modern field 'on a considerable scale', buying a landscape by Manet and two views of Venice by Monet in 1912; three *Nymphéas* by Monet and a Renoir, in 1913; more works by Manet, Monet and Renoir, and two Rodin bronzes in 1917; works by Cézanne and a van Gogh landscape in 1920. 'Qualitatively as well as quantitatively,' Cooper judged, 'this was unquestionably the most important collection of Impressionist and post-Impressionist pictures acquired by any single English collector before 1920.'

Emile Bernheim wrote to Gwendoline on 12 March 1920: 'I think that you now possess a remarkable collection of modern pictures and I should be pleased if, during one of my next visits to London, you would allow me to see your collection in one room, all these pictures we love so much in Paris.'

<center>✍</center>

Hugh Blaker detonated his celebrated Cézanne bomb in January 1921. On Gwendoline's behalf he offered *The François Zola Dam* as a loan to the National Gallery. Rejecting the offer, the gallery passed it to the Tate which lamely cited a lack of space and refused it. Gwendoline was disappointed. As an ardent British admirer of Cézanne, Blaker publicized the Tate's refusal in an angry letter to The Observer. He saw a clear case of establishment bias. The artillery of art moved into position. D S MacColl, a Tate trustee, wrote disdainfully of Cézanne in the Saturday Review. In May, under the headline 'Cézanne and the Nation,' the influential Burlington Magazine fired back with a report that English critics were now divided into camps, for and against Cézanne. It added that 'a gallery of modern art without a Cézanne is like a gallery of Florentine art without Giotto'. The article commended Gwendoline's generosity and placed her in the ranks of collectors of 'faith and passion'. Looking back at the Cézanne affair seventy years later, Art News in New York said 'the Davies sisters stood alone in Britain as major collectors of French avant-garde'.

At the Burlington Fine Arts Club in 1922 Roger Fry staged an exhibition he called 'The French school of the last hundred years.' It included Manet, Renoir and Gwendoline's Cézannes. Fry wrote that *The François Zola Dam* was 'one of the greatest of all Cézanne's landscapes' and chided those 'who have spent their time abusing Cézanne instead of looking at him'.

MacColl felt the wind against him and went to the exhibition to reconsider the Cézanne. 'About Miss Davies's landscape,' he wrote in the

Saturday Review, 'I have a preliminary admission, I had rated it too low.'
He was later instrumental in getting the Tate to accept the painting on loan
in June 1922; and he described it as 'Miss Davies's very beautiful landscape'.
It was the first Cézanne exhibited at a national gallery in Britain. Later the
Tate accepted more paintings from the Davies collection including works
by Renoir and Monet as well as Cézanne and others. Blaker remembered
that ten or fifteen years earlier he had begged Gwendoline to buy Cézanne
and 'at last she bought three. Therefore I have something to do with the
first introduction to the public in our state galleries. Forgive the mention
of it. I am so modest!'

Paul Cézanne 1839–1906    *The François Zola Dam* 1870s
Gwendoline's purchase of this famously strong painting was brave and imaginative. Rejection of it by the National
Gallery and the Tate underlined the Davieses' place at the art frontier

The textile magnate Samuel Courtauld experienced an instant exhilaration when he saw *The François Zola Dam* at the Burlington for the first time. 'I knew nothing yet of Cézanne, but I was initiated in a curious way.' He related that a friend who had been a wartime airman pointed out the painting to him. 'Though genuinely moved he was not very lucid, and he finished by saying, in typical airman's language, "It makes me go this way, and that way, and then off the deep end altogether!" At that moment I felt the magic and I have felt it in Cézanne's work ever since.' In 1923 Courtauld gave the Tate £50,000 to buy similar works. During the 1920s he himself formed a magnificent collection of Impressionist painting and in the 1930s endowed the Courtauld Institute of Art. There was no doubt in his mind that paintings spread a civilizing influence and he saw a clear obligation to share them.

Hugh Blaker added a wry postscript in 1926. He wrote to Gwendoline saying that he had met Charles Aitken, director of the Tate, who was 'very cheerful and smilingly referred to the Cézanne episode and is evidently reconciled to the anarchist painter!'

# Music mansion

The boom in colliery output in 1919 was a cruel false dawn of the 1920s in Wales. A third of the families in the southern valleys owed their living to coal and with the onset of the depression in 1920 they paid the brutal price for a lopsided economy. Ahead lay almost two decades of mass unemployment and an exodus from a shrivelling land. Gwendoline and Margaret recalled the financial anxieties that broke their father in the 1890s. Gwendoline's letter to Tom Jones in April 1921 seemed theatrical: 'No more pictures for ages! Both of us terribly in debt! We shall find ourselves in the workhouse at this rate.' But, as she told him six months later, she was minded to direct more money into the alleviation of suffering in the coal mining districts, the source of the family's wealth. In a letter thanking him for telling her about paintings by Augustus John she said: 'I have not bought any for 18 months. We simply cannot in the face of appalling needs everywhere - Russian children, Earl Haig's ex-soldiers, all so terribly human - after all it is humanity that needs help and sympathy isn't it?'

The Davieses' collection of French Impressionist and post-Impressionist art was at that time the largest in Britain. After thirty-three purchases in 1920, they bought four in 1921. Gwendoline acquired only a Daumier drawing. In 1922 they purchased a mixture of fourteen etchings, drawings and oils. The prize was a Turner oil. Hugh Blaker wrote to alert the sisters

that *The Beacon Light* would be on sale in July and it seemed 'to call for inclusion' in their set of Turners. 'The price, however, will be very high. Eight to fifteen thousand perhaps.' This was an overestimate but the price was still steep, as Turner prices always were. In his diary on 7 July Blaker recorded 'an exciting afternoon at Christie's. Bought Turner's *Beacon Light* from the Brocklebank Collection for 2,500 guineas'. Turner painted it on the Kent coast, probably between 1835-40. Torn by the wind the flame of a clifftop beacon holds centre stage in the drama of angry white waves and a malevolent sky.

Edgar Degas 1834-1917

*Dancer looking at the Sole of her Right Foot 1890s*

Accustomed to the traditional classical nudes in sculpture, many found Degas's frank avant-garde approach disturbing

In 1923 the sisters bought eight paintings and sculptures. Gwendoline purchased her only works by Degas, two small bronze figures for which she paid £800. One was *Study for a Dressed Dancer* and the other *Dancer looking at the Sole of her Right Foot*. Dancers, horses and women bathing were favourite subjects for Degas, a self-taught sculptor absorbed in the challenges of movement. 'If the leaves of trees did not move,' he wrote to his friend Henri Rouart, 'how sad the trees would be, and we too.' In keeping with the Impressionist ideal he aimed to capture the instant of movement. The girl looking at her foot teeters on one leg. In the other sculpture, too, tension assists the dancer's elegant pose.

In November Gwendoline paid £6,000 for *The Disrobing of Christ*, a sixteenth-century work attributed to El Greco. It was later judged a product of the studio rather than the work of the master. In 1924 the sisters bought two small sketches by Boudin, *Village Market* and *Beach at Trouville*. Boudin was not an Impressionist but an artist of the littoral

Louis Eugène Boudin 1824–1898                                    *Beach at Trouville* 1890
Boudin painted often at Trouville. This is typically loose and lively. Margaret bought it in 1924

who mostly painted beaches and boats along the Normandy coast and was renowned for his studies of reflections in water. He observed the budding talent of the young Monet in the summer of 1870 and encouraged him to paint in the open air. For his part Monet recognized that 'there was much to be learned from men like Boudin. With infinite kindness he set about my education'.

Gwendoline bought no pictures in 1925. In February of the following year R R Tatlock, editor of the Burlington Magazine, wrote a tribute to her: 'Pioneers are always admired and on that score the fine preparatory work performed at the Tate by the late Sir Hugh Lane, and the cutting of the first real sod by Miss Gwen Davies are to be perpetually remembered.' She ended her collecting in March 1926 with her purchase through Hugh Blaker of *View in Windsor Great Park* by Richard Wilson. Wilson was a clergyman's son born in 1713 at Penegoes, near Machynlleth. He trained as a portrait artist and painted for seven years in Italy, his work influenced by the serene landscapes of Claude Lorrain and those

of Francesco Zuccarelli and Claude-Joseph Vernet. In his turn Wilson influenced Turner, Constable and John Sell Cotman. A founder-member of the Royal Academy, he composed English views and pioneered the painting of Welsh mountains. Thus Gwendoline drew the line under her collecting with a salute to the greatest of the landscape painters of Wales, a fellow-native of Montgomeryshire. Margaret bought no pictures from 1928 to 1934. In the meantime she and Gwendoline spread the appreciation of art through their loans of paintings to exhibitions and galleries.

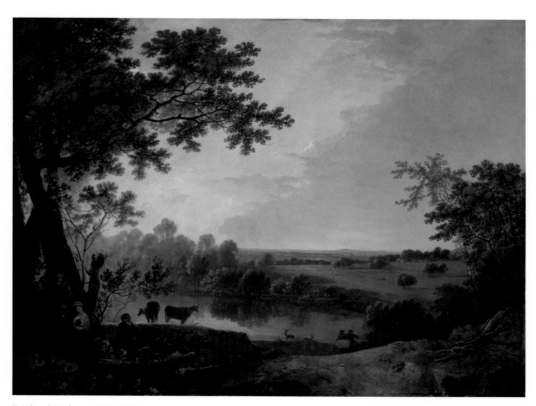

Richard Wilson 1713-1782
Champion and artistic discoverer of his native land

*View in Windsor Great Park 1770s*

As energetic as ever David Davies committed himself to heroic bouts of writing and speaking for the League of Nations. He gave £30,000 to found the Welsh national council of the League of Nations Union. Meanwhile, in 1921, he and his sisters endowed a chair of tuberculosis research at the Welsh National School of Medicine.

He met Henrietta Fergusson, known as Rita, during a grouse-shooting holiday in her native Perthshire. 'A romance of the moors,' the Montgomeryshire Express called it. The couple married on 9 December 1922 in the Crypt of the House of Commons. It was one of David's rare visits to Westminster. His parliamentary seat needed little upkeep. Montgomeryshire's voters returned him unopposed in the elections of 1918, 1922 and 1923.

In 1923 he told his stepmother and sisters that he and Rita wished to leave Broneirion, his grandfather's home, and cross the river to Plas Dinam, the house his father had willed to him. Eirene White said this was 'badly received' by the sisters, and it was no doubt a wrench for them to leave 'their home sweet home' after thirty-eight years. Gwendoline wrote to Thomas Jones about David: 'How can he go about advocating the League of Nations and Peace on Earth and behave as he does at home – passes our comprehension.' The sisters moved to Gregynog in the spring of 1924. Elizabeth Davies preferred to settle in Broneirion. Between 1923 and 1929 David and Rita had four children: Mary, Edward, Islwyn and Jean.

The move decisively shifted the axis of the sisters' lives. Their permanent presence at the heart of things enhanced Gregynog and the Gregynog idea. Gwendoline lived in the east wing, her bedroom

David Davies and Mike about 1922

window overlooking the gardens at the front. Margaret was in the west wing, the style of her room more austere than her sister's. They banished the Victorian and Edwardian clutter, installed modern bathrooms and furnished their rooms with simple light-oak chests, wardrobes, tables and chairs made at Brynmawr in south Wales by unemployed miners retrained as craftsmen. Quantities of Brynmawr cushions, stitched by miners' wives, added comfort and colour. From Plas Dinam they brought their plain mahogany furniture, antiques, Persian rugs, pictures and sculptures.

They directed the landscaping of their acres of woods and gardens and had Monet in mind when they created a water lily lake with a summer house and veranda. Gwendoline had a lifelong love of gardening and exotic plants. Margaret preferred homelier plants like sweet william and pansies. The poet Menna Elfyn sees something of the sisters' strength of character in the lake – 'like lilies they appeared delicate and still, yet beneath that beauty roots were taking hold, gripping the depth'. The sisters came often to the lake to watch the light and the waterbirds and to admire the lilies; as visitors do to this day. They also designed the Dell, a garden with a stream and a little refuge to sit in. Margaret's pleasure for many years was to put on her smock and broad sun hat, pack a small barrow with her paints and brushes, and set up her easel in the glades and gardens. The mature woodland around Gregynog is a Site of Special Scientific Interest where more than 130 species of lichen thrive.

Gregynog employed a cohort of local people as gardeners, estate workers, kitchen staff and housemaids. There was an estate manager, a boiler man and two men operating the turbines in the power house, Gregynog's private electricity supply. The first head gardener was a woman and there were up to twenty-five gardeners, some of them working in a one-acre walled garden cultivating fruit and vegetables, and in greenhouses growing vines, peaches, nectarines, melons, tomatoes and cucumbers. Pears and apples from the orchard overwintered in storerooms. Rabbits were raised to augment meat supplies. The sisters' gifts of fruit to the staff and their children became a tradition. 'They gave help generously and discreetly,' a gardener's son recalled. Children remembered the Christmas parties

in the village and the presents Gwendoline and Margaret gave: 'lovely books, much treasured', and 'Dinky toys, things you really wanted'.

Having such a large number of paintings on their walls the sisters had an abiding fear of fire. Eighteen workers were trained and equipped as a fire brigade, complete with a fire engine and an alarm hooter. Moving burning coals from one room to another, however, was considered an economy measure rather than a fire risk. In winter, before the sisters were called to dinner, a maid carried hot coals from a sitting room to fill the fireplace in the dining room. Meanwhile, Margaret herself removed coal from a fire if she felt it was piled too extravagantly.

The Davieses were car enthusiasts from the dawn of motoring. One of the family's chauffeurs started his working life as a coachman and made the transition from horses to horsepower. Edward Walters found a job at Gregynog in 1925 helping Mr Harrington, the chauffeur, to restore the 1908 Rolls-Royce Silver Ghost. In the 1930s it became too expensive to run and was replaced by a Daimler and a Humber. Edward Walters's son remembered that his father and other drivers were 'kingpins, rather like airline pilots today, with smart uniforms made by a tailor in Newtown'. They met the trains, drove the sisters to their flat in London, took Gwendoline to a nursing home in Ruthin for treatment and often drove the sisters and their stepmother on tours of the countryside. The Daimler was eventually replaced by an eight-cylinder American Packard capable of seventy miles an hour. Gwendoline liked to be driven sedately and preferred riding in the Humber with the older chauffeur at the wheel. Margaret liked a dash of speed and opted for the Packard, driven by the younger chauffeur.

At Christmas the drivers delivered the sisters' presents to the homes of staff members and villagers, gifts of sugar and tea, shoes for the children. Former servants remembered that 'the ladies' were never ostentatious and ate and dressed simply. 'I think they were very modern women,' one villager said, 'women before their time, musical and artistic, and they did their bit in the first world war in the French canteen.'

<div align="center">⚬</div>

A locked mailbag passed to and fro between Gregynog and the post office in Tregynon. Gwendoline and Margaret started their working day after breakfast, reading letters, discussing the estate with their manager and writing cheques for charities and appeals, recording hundreds of donations in their impeccable ledgers. During the war they had given money to hospitals, Belgian refugees, victims of Zeppelin raids, Comfort for Troops, Comrades of the Great War Association, prisoners of war and Serbian refugees. They responded to requests for help in raising war memorials in Wales and gave £500 towards a memorial to the Merionethshire poet Ellis Humphrey Evans, killed in action in 1917. They helped both the British Red Cross and the French Red Cross.

After the war they sent donations large and small to more than 500 charities: the Budapest Relief Fund, the Salop and Montgomery Discharged Prisoners Aid Society, the Shelter for Fallen Girls in the

Cue for music: the sisters transformed the masculine billiard saloon into a music room complete with an organ

Rhondda, the Peace with Ireland Council, the Llandinam Curates Fund, more than £7,000 to the Russian Relief Fund, a small sum to the Rhondda Wireless Society. David Davies began his substantial support for the League of Nations, giving £1,000 in 1918 and £15,000 in 1919. His sisters, meanwhile, supported a benevolent institution for governesses, a Factory Girls Country Holiday Fund and the Society for the Assistance of Ladies in Reduced Circumstances. Between 1928 and 1942 the Davieses gave £25,000 to hundreds of chapels and other religious causes.

A large measure of their charity began at home in Wales and in their native Montgomeryshire. In fulfilment of a vow David Davies made in the trenches of the western front the family funded the building of a concert hall that in its time was a wonder of Wales. Noting the stoicism of his fusiliers in 1915 David Davies promised 'to do something' for them at home. In 1919 he founded the Montgomeryshire County Recreation Association from which grew sports fields, village halls, football teams, choirs and music groups. Most famously it discovered a giant wartime aircraft hangar in Lincolnshire, bought it for £250, dismantled it and transported it by rail to Newtown. David Davies gave £3,000 towards the rebuilding and in July 1921, three months after it was bought, the first Montgomeryshire festival was staged in it under the command of Walford Davies. This County Pavilion had 6,000 seats and fine acoustics, and was a venue ideal for great concerts and works like Handel's Messiah and Bach's Saint Matthew Passion. In preparation for the festival, concerts, choirs and soloists met at Gregynog to be drilled by Walford Davies. In later years concerts at the County Pavilion drew leading symphony orchestras conducted by Michael Tippett and John Pritchard. John Barbirolli, who conducted the increasingly famous Hallé, loved both the pavilion and the Montgomery hills. In its day the pavilion was also a hall for dancing, boxing, drama and opera. It closed after fifty years in 1973.

◊

Music was the heartbeat of the Davieses' Gregynog. In the 1920s and 1930s the house was a huge musical instrument alive with violins and voices. The genius in this was Walford Davies whose energy filled all spaces. He called his job 'a lovable responsibility'. Some remembered him in Royal Air Force uniform, a figure blue and looming, known to all as 'the Doctor'. In his time he had discussed choral singing with Brahms himself. Walford Davies visited Gregynog several times a year for twenty years. As a Pied Piper and popularizer, he aimed to take music into every home and heart in Wales, drawing on the Welsh affection for choral singing to inspire a broader love for music. A photograph of 1922 shows him in an open charabanc at Gregynog, setting off with a choir. As a 'missionary' of music he was not popular with everyone in Wales; indeed there was a waspish buzz of anti-Walford grumbling and resistance. The sisters, however, adored him for his leadership and his commitment to the Gregynog idea. He chaired the annual conferences of the National Council of Music at Gregynog from 1921 to 1938 and insisted that they should be events of song and concerts as well as talk. He was knighted in 1922. As soon as public radio began in the 1920s he was at the microphone developing an auxiliary career as an engaging broadcaster of talks and record programmes and a champion of 'wireless orchestras'.

Two stalwart Gregynog festival performers: Adrian Boult, conductor of the London Philharmonic Orchestra, and Lascelles Abercrombie, professor of English at Leeds, London and Oxford, who died in 1938

He fitted perfectly into Gregynog's teetotal ways and drank milk at rehearsals. Not for him the custom of certain guests who met clandestinely in a bedroom to sip Scotch from

tooth glasses; or said that they were off for a run into the country, meaning a visit to The Buck in Caersws. Gregynog's rules applied to all. Asked at dinner whether he wished to drink orange juice, lime juice or water, a French guest responded bleakly: 'What does it matter?' Musicians performing at Gregynog festivals and other concerts knew they had to bring their own drinks, discreetly concealed. 'Luggage was often a little heavier when guests arrived, compared with when they left,' the sisters' niece Mary remembered. The Davies family saw to it that local inns had no licence. On evenings when he was off-duty, Anderson, the butler, walked four miles to the Beehive in Manafon and carried a briefcase for the bottle he took back to Gregynog.

To Aberystwyth and Gregynog Walford Davies brought composers Edward Elgar, Ralph Vaughan Williams, Edward German and Gustav Holst; and the conductors Henry Wood and Adrian Boult. He gave up the chair of music at Aberystwyth in 1926 but was committed to what he called the 'Welsh plough' and continued as director of the National Council of Music for the rest of his life. In south Wales in the 1930s he founded the famous Three Valleys Festival of concerts which shone a light in dark times. He succeeded Elgar as Master of the King's Musick in 1934. His best-known composition is the Royal Air Force March Past. He confessed an allergy only to opera.

Like many, but not all, Walford Davies enjoyed the hour-long Gregynog Sunday morning services of two hymns, prayers and poetry prepared by Gwendoline and Margaret. Since the house was not consecrated Roman Catholics were free to attend. The services were not designed as interdenominational; it simply happened that way. Sometimes they took place in the garden or the library or the seventy-seat music room that had once been Lord Joicey's billiards parlour. Here the sisters installed an organ built by Frederick Rothwell. Gwendoline played it often, sometimes for friends, sometimes accompanying songs sung by Dora Herbert Jones.

From the Davieses' passion for music came Gregynog's choir of twenty-eight voices founded in 1929. Its strength increased to forty for big events. The story that Gregynog advertised for gardeners with good

Gregynog in London: the Gregynog choir took part in the 1938 Empire Day royal command performance and sang Holst's O Spiritual Pilgrim, dedicated by the composer to Gregynog

tenor voices has the status of an honorary fact. Nevertheless estate staff were the core of it and the choir certainly belonged to the house. 'The man who mowed the lawn was one of the basses,' Dora Herbert Jones, the choir secretary, said, 'and the girl who brought your morning tea was in the altos.' Gwendoline told Adrian Boult that a bass soloist was so good that although there was not enough work for a second estate carpenter she couldn't let him go. The singers practised for two hours on Fridays throughout the year except in August. Dora Herbert Jones and the sisters were among them, Gwendoline an alto and Margaret a soprano, and they never missed choir practice. Gwendoline saw to it that the choir cut a dash, the men in dark suits with black bow ties, the women charming in long cream-coloured dresses.

Most of the men could not read musical notation. They 'worked like beavers' to read tonic solfa or they learned by ear. 'Sing listeningly,'

Walford Davies instructed as he guided them to a mastery of the Saint Matthew Passion, Vaughan Williams's Mass in G Minor and Brahms's Requiem. Tom Jones said: 'He made the simplest country singers rich with the wealth of great composers by waving his magic wand.' Gregynog's voices and music gathered strength, reaching a pinnacle in six magnificent festivals of music and poetry, amounting to twenty-eight concerts, staged in June or July from 1933 to 1938. Elsie Suddaby, Sir Steuart Wilson and Keith Faulkner sang solos. In 1933 Gustav Holst wrote O Spiritual Pilgrim, for soprano and chorus, especially for Gregynog and as a tribute to the sisters. George Bernard Shaw asked in his puckish way if there were a padded room in which he could escape Holst's music. Everyone in the festival audiences was a guest of the sisters, either staying in the house or in local temperance hotels with their bills paid by the Davieses.

Gregynog octet: clockwise from top left, Abercrombie, Shaw, Dora Herbert Jones, Tom Jones, Gwendoline, Margaret, Jane Blaker, Irene Jones

Those accommodated in the house found books set out in their bedrooms selected to match their tastes, with a note saying the staff enjoyed their work and needed no tip. Guests dressed for dinner, of course, and wore whites on the tennis courts. The festivals had their serious and solemn aspects and also a strong streak of hilarity with after dinner sing-songs, Walford Davies's musical burlesques, and Bernard Shaw reading his own plays and taking all the parts. Gwendoline described an evening with Mr and Mrs Shaw: 'We enjoyed them immensely. We just let him talk and we talked to her!' Lascelles Abercrombie read poetry at the festival Sunday services. He was tall, skinny and apparently colourless; but Dora Herbert Jones commented that when he stood in the music room and started to speak it was as if a ship had been launched: he was unstoppable and unforgettable. He read at every festival.

Writing in the programme for the third festival in 1935 Gwendoline asked: 'Shall we not fill the world with beauty again? Cheating despair, let us fling out across the ether songs of glorious hope and courage, till the sound-laden air is so charged with beauty that there is no room for despair!' A visit to Gregynog's music festival, said a writer in the Liverpool Daily Post in 1936, was in the nature of a pilgrimage. 'The beautiful estate, the house with its treasures of classical and modern painting, everything in the atmosphere of the place contributes to that rare experience, art for love's sake.'

As cars arrived at Gregynog's door, servants emerged to carry luggage and guide guests to their rooms in the house and its annexe. The pleasures that awaited all who travelled to Gregynog for music and conferences were, first, the abundance of azaleas, hydrangeas, delphiniums and sweet peas; and second, the profusion of the sisters' art. *La Parisienne* was there, as if in the role of a welcoming hostess. Visitors in the 1930s recalled the house as a gallery, the music room's array of works by Turner and Manet, the sublime Monet water lilies and Pissarro's painting of the Pont

Rodin                    *Eve* 1881
Derived from Michelangelo's depiction
in the Sistine Chapel, Eve is in disgrace,
ordered out of the Garden of Eden

Neuf. Seven Corots and a Morisot hung in the drawing room, portraits by Raeburn and Romney in the hall, several Whistlers, and four magnificent Rodin bronzes.

Robert Blayney remembered the carnival of colour in the music room, Turner watercolours with small blinds to shade them from the light, Daumiers hung between the windows so that their dark tones were better illuminated. 'It was Miss (Margaret) Davies who lit my enthusiasm for French impressionists,' he remembered. 'She explained exactly what she loved about painting. She asked me to lift a Monet off the wall and carry it outside and prop it on a bench so we could see the colours in good light.' Others recalled Millet's *The Gust of Wind*, a favourite of Margaret's, on an easel on the music room stage, a Sisley in the drawing room, and Derain's *Madame Zborowska* over the drawing room fireplace. For the young Swansea artist Ceri Richards the visit he made to Gregynog in 1923 was his memorable first encounter with Impressionist art. 'I was staggered by the sight of the superb paintings and the bronzes by Rodin, fascinated most of all by Monet. Imagine their effect on someone who'd dreamed of great painting but had seen none at all.' A musician as well as an artist he became an internationally celebrated Welsh painter.

For all their shyness Gwendoline and Margaret enjoyed gathering people in their home to celebrate music, art and talk. Ian Parrott, Gregynog professor of music at Aberystwyth university college, called them 'gentle sisters who dispensed great beauty in hushed undertones.' From 1921 the house was a forum where minds gathered to confront the pity and waste of disheartening times. Wales had never had such a rendezvous. Welshmen had hitherto journeyed to London and the lapping Thames to discuss Wales, so that there was a sense in which Wales itself seemed over the horizon. Gregynog conferences were events where Wales learned to talk about Wales and suggested a future devolution of discussion and action. A conference on broadcasting in 1937 turned into a stormy experience for Sir John Reith, the god of the BBC, who was little used to dissent. A traffic of speakers arrived at Gregynog for the Distressed Areas conferences and others on education, health, unemployment, missionary work and music. If anyone needed reminding of the human question they had only to read the words of a reporter of The Times writing from Merthyr Tydfil in 1928. 'These out of work miners are cultivated people with self-respect and pride in home cleanliness and feel the degradation of their sudden poverty. They are starving; not starving outright but gradually wasting away through lack of nourishment.'

The League of Nations conference was 'a talking shop' but 'fairly high-powered' for those days, according to Alun Oldfield Davies who attended regularly. He noted the 'dramatic contrast' between the uplifting Sunday services and the gathering of men in a smoke-filled room swapping 'some of the filthiest stories I'd ever heard'. Leaders of Welsh life, deacons and other respectable people would 'unburden themselves of a weight of guilt, dredging their subconscious and dragging up perhaps something of the spirit of the trenches'.

If Gwendoline knew nothing of the scandalous stories, she was aware of the late-night talk; and sometimes disappointed by it. 'All sat around the fire,' she reported to TJ in 1925, 'and smoked and talked and talked and smoked until midnight each night - delightful people with plenty of ideas, but vague, nebulous and undefined. They arrived and left at all

hours of the day and night; one, landing by bicycle near 2 a.m., succeeded in waking R Hopkin Morris MP by throwing gravel at his window.'

Still, Gregynog was doing something. 'I look back in wonder at Gregynog,' said Ernest Rhys, the creator of the Everyman's Library, 'so rare is it to find wealth so wise and culture so kind.' He wrote a comment in the visitors' book: 'When ideas failed us we stared at the Turners or the Botticellis or at the Whistlers – or at the riot of rhododendrons and azaleas; or the ladies of Gregynog gave us music.'

The visitors' books date from 1921 and record the presence of authors, academics and musicians. Among the conductors and composers were the architect Sir Herbert Baker, the novelists John Buchan and E M Forster, the actress Joyce Grenfell, the artist Paul Nash. Anthony Blunt, a twenty-one year-old Cambridge undergraduate, signed the visitors' book in June 1929. He would certainly have lingered over the pictures, for it was said of him that he was one of the few Cambridge students known to have any interest in painting. This was five or six years before he became a chrysalis Soviet spy.

Hugh Blaker taught some art classes at Gregynog. With the Davieses' collection of French painting complete he was no longer their active go-between. He went to a boxing club in London from time to time and sketched the boxers there. One of these was a boy of sixteen who had been born in a London slum and knew no father. Blaker gave him a home and in 1924 became his unofficial guardian. He paid for his training at a stage school and found him a place with a touring Shakespeare company. He also introduced him to poetry and painting and sent him to Imperial Service College in Windsor. In due course his young ward married and lived with his new wife in a house adjacent to Blaker's home in Isleworth, near London. Their daughter was born there. The young man prospered as a stage and film actor and later had a television career with the BBC. He was William Hartnell, the original Dr Who of the 1960s.

# Lunch in the Blue Room

wendoline and Margaret founded the Gregynog Press in 1921. They knew nothing of typography, printing and bookbinding, nothing of the art of managing artists. Gwendoline embarked on the romance of a private press publishing exquisite books. Margaret was on the press board but did not share her sister's passion. Thomas Jones did. He was chairman of the board. Without his drive there would have been no press at all. The whole enterprise, he decided years later, was 'an untidy, emotional, family and friendly affair which only slowly learnt business habits and when it had learnt them it closed down'.

An early hope that Gregynog might support potters and furniture-makers in a craft community quickly withered. The press, however, took root. A print shop and bindery grew in a warren of rooms in the converted stables and coach house. Tom Jones wanted a Welshman to run it. Hugh Blaker recommended Robert Maynard, an artist he knew, and had his way. He had seen Maynard's work before the war and supported him with gifts of paints. Maynard's wife was French and while visiting her parents in Paris Maynard saw Impressionist paintings for the first time. An officer in the Royal Fusiliers during the war, he was wounded in France.

He visited the sisters at Plas Dinam and in their apartment in Buckingham Gate. Both their paintings and their modesty astonished him. 'Very different from what I had expected,' he recalled in letters to Tom Jones. 'There was no side, no parade of wealth, nothing to suggest

they owned the whole bag of tricks. They were simple and unaffected but just a trifle more earnest than I thought necessary. I liked them for it and quickly sensed the immense possibilities of the plans they were making. The evidence of their wealth was more apparent at the flat than in the wilds of Montgomeryshire, and it all went to my head!'

Winifred Coombe Tennant experienced a similar revelation. She met Gwendoline in February 1921 and travelled with her to Plas Dinam. At first glance she thought it 'a cold house full of fine things and dead in spirit'. Next day, however, she saw the paintings: Monet, Millet, Whistler and Turner. 'Such pictures in this house! oh! the joy of them! I wander as in a Temple standing before each.' Two days later she wrote: 'A marvellous collection and thank God it is in Wales!' She and Gwendoline walked in the gardens and talked of Gregynog and their mutual friend Tom Jones. She wrote it all up in her diary and concluded that shy Gwendoline was 'a precious soul'.

Gwendoline and Margaret sent Robert Maynard to London for a year and a half to learn printing and wood-engraving. His first task was to design the Gregynog Christmas card for 1922 and print 120 copies on a hand press. For illustration he cut a wood engraving of the hall in its setting among the hills and woods. Beneath it he printed twelve words by the religious writer Ellis Wynne, d. 1734:

> A ddarlleno, ystyried;
> A ystyrio, cofied;
> A gofio, gwnaed;
> A wnel, parhaed.

In English they say:

> Let him who reads, ponder;
> And pondering, remember;
> And remembering, act;
> And acting, persevere.

Illustrated cards, festival programmes, orders of service and other ephemera became a staple of the press's output. Books emerged in limited editions of a hundred to 500 copies, lovely to the eye. In 1924 Maynard's friend Horace Bray, a stage designer, joined him as resident artist and between them they designed and illustrated eighteen books. Artistry flowered and there was a hum of contentment. The 'press gang', as it was soon known, the printers, binders, colourists and engravers, had lunch at a communal table in what was called the Blue Room. As controller of the press Maynard was a contented inky bee in Gwendoline's hive. Looking back on these early years he thought of them fondly as the happiest of his career. 'The press means so much to me now,' he wrote to Tom Jones, 'that I am impatient at anything which comes to interrupt what I think of as my real work here.' Jones himself called the Gregynog Press an 'experiment' attempting all the arts that make a book. 'It casts its own type, designs and cuts initial letters, makes marbled papers, designs and executes the bindings. The result is a unity and harmony. The craftsmen have sought after excellence and made no compromise with meanness.'

Private presses were like the rare Snowdon lily that blooms only in rocky niches. William Morris's Kelmscott Press, the father of them all, drew its inspiration from fifteenth-century printing and published fifty-three books. The Golden Cockerel Press, 1920-60, celebrated modern wood-engraving. The Ashendene Press, 1895-1935, was a gentleman's hobby. The Gregynog Press earned international respect for the taste and perfection of its books.

Gwendoline's quest was beauty and perfection and for her the progress of the Gregynog Press was often an emotional experience. In joy, anxiety and crisis she wrote frequently to Tom Jones. The first object of the press, she said to him in July 1924, 'was to unlock the treasure house of Welsh literature, romance and legend and make it accessible to the English-speaking public. It is worthwhile producing a beautiful thing for

its own sake. We consider certain Welsh things are worthy of a beautiful setting. We do not want any personal profit, but would like to feel that the Press will be able to pay its own way. Indiscriminate wholesale giving of money does more harm than good. Take music. Had we handed the money over to the people we would have been acclaimed as benefactresses of the nation. You can lead a horse to water but the Queen cannot make it drink. We have led the Welsh horse to the clearest brook, yet he has tossed his head and walked straight through churning up all the mud and stones. He is so self-complacent, so self-sufficient – so ignorant – how are we ever to going to convince him he is thirsty. Oh TJ we have so much to give that isn't money and all that life seems to demand of us is just money, money and yet more money'.

The press printed its first book in 1923, the lyrical devotional poems of George Herbert of Montgomery, d.1633. Walford Davies chose them. Maynard cut the frontispiece engraving and also the press's colophon, depicting a fir-topped hill with the interlocked letters GG set upon it. GG was Gwasg Gregynog, gwasg the Welsh word for press. John Mason bound the pages. In 1924 the press printed poems by Henry Vaughan, d.1695, and in 1925 works by John Ceiriog Hughes, d.1887, poet and Montgomeryshire stationmaster. There was never any firm editorial policy and no attempt to develop a recognizable Gregynog style. Maynard had a Monotype machine to cast a variety of typefaces and these and the handmade papers and bindings were chosen to suit the text. Bembo, for example, was a typeface with five centuries of tradition, first used in 1495. Poliphilus, dating from 1499, was particularly suited to Welsh text and was used in Gregynog's outstanding printing in 1929 of Psalmau Dafydd. These psalms were first compiled in Welsh in the sixteenth century by Bishop William Morgan, d.1604, the great translator of the Welsh Bible.

The steadfast and talented George Fisher replaced John Mason as bookbinder in 1925 and stayed for twenty years. Herbert Hodgson arrived from London to take up the post of printer in 1927. A craftsman of rare skill, he had just printed the first edition of T E Lawrence's Seven Pillars

Gregynog exotic: Robert Maynard's hand-coloured frontispiece for the Stealing of the Mare, published 1930

THE REVELATION OF SAINT JOHN

HOLY, HOLY, HOLY, LORD GOD ALMIGHTY,
WHICH WAS, AND IS, AND IS TO COME

Brilliant, startling, controversial: one of Blair Hughes-Stanton's wood engravings
for The Revelation of Saint John the Divine, published at Gregynog, 1933

of Wisdom. At Newtown station he climbed into a horse-drawn cab but his cockney mangling of 'Gregynog' baffled the driver who circled hopelessly for half an hour before returning him to the station. Fortunately a Gregynog chauffeur arrived and rounded him up. Hodgson's accent so fascinated the press girls that, as he related, 'they kept making me talk'. Handy with a banjo he started a jazz band called The Venetians and travelled to gigs on a motorcycle with a sidecar. Gwen Edwards, one of the local girls who joined the press from school, recalled his infectious banjo rhythm. 'At Christmas we girls decorated the bindery with holly and turned the mats back. We and Mr Fisher started dancing. He had never danced before Gregynog, but he took it up very seriously and attended all the dances, the sixpenny hops, every week.' The dancing reflected the atmosphere: most of the staff were young and happy in their work.

For Maynard, however, the Gregynog idyll soured after a few years. Gregynog was an island among the trees and he and some of the others began to feel isolated. They really did need to get out more. But only one bus a week ran into Newtown from Tregynon and such limited access was irksome. Maynard was profoundly irritated by Thomas Hughes, the estate manager with blue-tinted spectacles, known as 'the little man'. Hughes was in charge of car trips into town. 'To extract the loan of a Gregynog car from Hughes,' one of the staff remembered, 'was to draw blood from a stone.' Hughes, rather like William Burdon Evans, the business manager, harboured an antipathy to the press and its artists. Gwendoline observed Maynard's restlessness and diagnosed 'a bad attack of swelled head'.

Maynard completed his last book in December 1928. This was the Rubaiyat of Omar Khayyam, the eleventh-century Persian quatrains, rendered into Welsh by the Anglesey poet Sir John Morris-Jones, a scholar with ironclad views on printing, illustration and typography. He and Maynard never met and wrestled, comma by comma, in long correspondence. Sir John found fault with Maynard's engraving of Omar's beard, judging it too youthful. Maynard re-cut the block to no avail. 'I do not think,' wrote Sir John, 'that a beard like that of a goat is at all correct for an old Persian. A Persian beard is full: it spreads out under the ears and

ends either square or with angles rounded off. Perhaps it might end in an obtuse angle.'

Maynard informed Tom Jones that he was weary of weekends spent amending the engravings. He prayed that Sir John would like the book; but 'somehow I ha' ma doots'. At last the press sent four finished copies. Sir John immediately wrote a letter informing Maynard that he disliked the look of the ink. On closer inspection he discovered to his anguish a 'damnable' error, a missing F. Maynard countered that this was a proof-reading error on Sir John's part. Sir John bowed graciously. 'Peccavi!' he wrote. 'The fault is mine.' Maynard arranged to reprint offending pages and restore the missing F. Sir John wrote from Anglesey that he looked forward to a faultless copy. Before it reached him, however, he died.

Maynard at last resigned. 'Once he leaves this place,' Gwendoline wrote to TJ, 'he is leaving for good.' The press staff, however, were sorry to see him depart. Gwen Edwards remembered his farewell for the rest of her life. 'We were fond of Mr Maynard, he was very fair. We were in tears, of course, all we girls. There was Iris, Sybil and myself, seventeen, and he kissed us goodbye, each in turn. Coming back across the fields, we vowed, then, all of us, that we would never let another man kiss us.'

Gwendoline and Margaret travelled in the Middle East in 1923. 'To awake and find yourself in Palestine!' wrote Margaret. They took a train to visit the cemetery in Gaza where their cousin Ivor was buried. 'Simple wooden crosses, sufficient reminder of those terrible days in March and April 1917 when our troops so gallantly stormed the town. Six years ago, but how short a time it seems.' They returned to the Middle East in 1928 with their friend Bertha Herring, taking a ship from Marseilles to Alexandria and Beirut, making adventurous car journeys to Damascus and across the desert to Baghdad. They saw the ruins of Babylon, stayed in Jerusalem, visited the Sea of Galilee and Nazareth and travelled to Petra. Gwendoline wrote to TJ that it was 'quite the most wonderful trip we have ever had'.

The Davies sisters had a desert adventure in their Middle East travels in 1928. From Baghdad at the end of the journey from Damascus Gwendoline wrote: 'My dear mother, It was a wonderful experience … 540 miles over sheer desert. The car was a large saloon with very comfortable chairs. Two chauffeurs took it in turns to drive. We watched the sun set – then rise. The chauffeur got out, lit a fire with sticks and boiled the kettle and I warmed up some excellent tinned sausages …

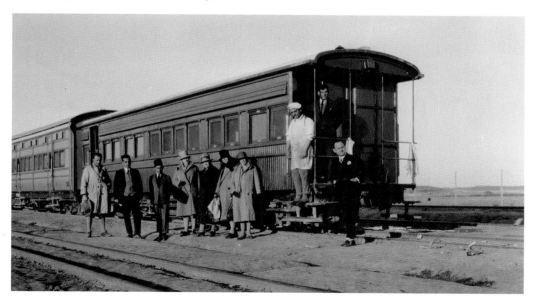

Damascus 29.2.28.

We had our first taste of the desert yesterday. We motored from here to Palmyra, 160 miles. It was very thrilling dashing along about 60 miles an hour! The ruins are very fine, right in the desert; there is an Arab village built right amongst them. We start for Baghdad on Friday. All well. It is still very cold. Gwen.

Mrs Ed Davies
Broneirion
Llandinam
Montgomeryshire
Grande Bretagne

Solomon's city: the sisters drove from Damascus to Palmyra, the ancient city of central Syria said to have been founded by King Solomon. Gwendoline sent a postcard to her stepmother, Margaret a letter

Th: 1-46     اوتيل الشرق الكبرى — خوام * دمشق (سوريا)     P.O.B. 43

# GRAND HOTEL D'ORIENT
## KHAOUAM

March 1ˢᵗ 1928.      Damas, le _____ 192

My dear Mother

As we leave tomorrow for Bagdad,
letters will take some time to reach from there,
so I am writing before starting, as there is
sure to be a post from here in a day or two.
So far we have had no letters, but I expect
Cookes will have sent them to Bagdad,
in case we should miss them. We have not
seen a newspaper either since our arrival
so have no idea what is going on in the
world! The weather I am glad to say
has improved on the whole, though today,
it is trying to snow just a little, a
rare thing at Damascus, but I think
it will not be much. Yesterday & the day
before, we had nice sun, though somewhat
cold still. We went off to Palmyre,

Tom Jones himself was meanwhile enjoying the fulfilment of his ambition to found a residential college for working class adults. In a time of slump, unemployment and class antagonism he had raised the money to open Coleg Harlech. It was part of his broader struggle to reconcile coal owners and labour. The Davieses supported him. The strike of 1926 had a brutal aftermath of hardship. The owners' attempt to weaken the South Wales Miners Federation by creating a company union, a scab union, led to conflict in a number of Ocean pits. David Davies was an owner more benevolent than most, but his company was associated with the scab union. In 1926 he had surgery for a duodenal ulcer.

Gwendoline's friend Dora Herbert Jones became secretary of the press in 1927. She loved both the job and her place at the heart of the Gregynog choir. Gwendoline admired and depended on her; but Dora's position, as a friend and employee, was ambivalent. 'Dora is vital to me in many ways,' Gwendoline told TJ. 'Our minds work together. She is a rapid thinker.' Dorothy Harrop, historian of the Gregynog Press, said Gwen and Dora had a rapport. 'Dora once said to Gwen: "You have always been lonely and you always will be." And Gwen responded: "How true."'

On 21 December 1928 Tom Jones's twelve-year-old son Elphin was killed by a car in London. TJ wrote to Gwendoline that day: 'You will have heard the dreadful news. The lovely life is ended – brutally, stupidly ... Don't try to write. We know that you will sorrow with us and be our friend for all time.'

The sisters often sought to show their gratitude for Tom Jones's friendship. 'I have been meaning to write,' Gwendoline said in March 1929, 'somehow I did not know what to say without hurting your feelings. We do appreciate your sense of reluctance in accepting our offer to cancel the

mortgage on your house, but please don't be vexed with us for suggesting it and don't I beg of you let it make any difference to your friendship for us, both of you. It is so fatally easy for us to give away money – it costs us nothing – at least not now.'

The second part of this letter, set out in chapter 4, was her painful recollection of her father's death thirty-one years before. 'When I look back on the years that are gone, I realize something of the price that has been paid. I can't say any more but think you will understand. I don't know why I am writing all this to you TJ. Life seems nothing but problems at present, and I don't feel as if I had the courage of his (her father's) strength to face them. When you next hear your socialist friends speak of the selfish capitalists – just think of what I have written before you agree with them entirely. The tragedy is that we have so much to give that is not money.'

At the end of December 1929 she wrote plaintively from Gregynog. 'We are dreadfully disappointed you can't come down – it's awfully lonely here just our two selves when everyone close around is busy with shoots, dances, dinner parties.'

William McCance, a Scottish painter and former art critic of The Spectator, replaced Maynard as controller of the press in 1930. He was married to Agnes Miller Parker, a gifted engraver, who made the remarkable illustrations for the Fables of Esope, one of the press's renowned books. Blair Hughes-Stanton, the twenty-eight-year-old son of the Welsh landscape painter Sir Herbert Hughes-Stanton, took the job of artist at £500 a year. He had illustrated Lawrence's Seven Pillars of Wisdom. His wife, Gertrude Hermes, was a sculptor and wood engraver of some distinction. Gwendoline meanwhile studied Hughes-Stanton's earlier work and was alarmed by the female figures. 'Oh dear!' she wrote to TJ, 'Do you think we can ever wean him from these delectable ladies? They would never do for Gregynog! That will have to be made perfectly clear. I am just boiling with internal rage.'

At Christmas 1930 Tom Jones and his wife were guests of the Astors at Cliveden in Buckinghamshire. Viscount Astor and his wife Nancy had met TJ during the Davieses' tuberculosis campaign and had become firm friends. TJ wrote to Gwendoline from Cliveden: 'T E Lawrence motored up. We talked Gregynog books. Found him all against the Blair Hughes-Stanton style of illustration. Must stop. Astors coming to tea.'

Hughes-Stanton illustrated eight books for the press. A board meeting decided to go ahead with his male nudes in The Revelation of Saint John the Divine. The twenty-four engravings he cut for The Lamentations of Jeremiah were strikingly avant-garde, many of the figures naked or exiguously draped. The production qualities of these books, the beautiful typography, Herbert Hodgson's printing and George Fisher's binding, placed them among the best of Gregynog's work. Burdon Evans wrote his blunt opinion of the illustrations: 'Some are very realistic and I do not like them.' In a note to Tom Jones he added: 'Any dislike I may have does not arise from prudery but because I think them ugly. I cannot express any opinion worth having on works of art - I only know what I like.' Gwendoline wrote to TJ: 'We don't want to lose Hughes-Stanton, he is one of the chief assets, but we can't allow him to do anything he likes.' She suggested he should be given other work, 'anything to get him away from his elongated females!' Hughes-Stanton's engravings for The Lovers' Song-book, with verses by W H Davies, were rejected as too erotic.

It was a time of friction and resentments at the press. Hughes-Stanton's marriage broke up. To the relief of the board he and McCance left after three brilliantly creative years. There had been too much excitement. It was easier for Gwendoline to impose her will on the Gregynog gardens than on the press and its artists. A private press devoted to beauty at all costs, and with a small and exclusive output, was not expected to make much money; but it turned a profit in 1929, 1930 and 1938, and over twenty years published 12,000 volumes.

# Gregynog gold

aying he was 'sick of politics' David Davies resigned his parliamentary seat in 1929. After twenty-three years in the Commons he directed all his energy to world peace. From the early 1930s the impotence of the League of Nations disillusioned him. His massive manifesto, The Problem of the Twentieth Century, declared that peace and security depended on an authority backed by an international police force. He founded a pressure group, the New Commonwealth Society, to promote his ideas, and each year wrote off its debts. Raised to the peerage in 1932, as the first Baron Davies of Llandinam, he gained a platform in the House of Lords as well as in the newspapers. Stanley Baldwin's wife asked Tom Jones if Gwendoline and Margaret were pleased by his peerage. TJ told her that they preferred plain David Davies. Mrs Baldwin 'found some difficulty in understanding this', TJ said, 'and I described the democratic and anonymous traditions of the family'.

Loss and grief struck the Davieses at the end of 1930: David's thirteen-year-old daughter Marguerite died at her school in Bexhill, Sussex. In this intense part of his life his impatience led to acrimonious argument with his sisters. He asked them to shoulder some of the cost of running Plas Dinam but they refused, citing the extent of their own charity commitments to people struggling in the depression. Gwendoline wrote to Tom Jones complaining that David's attitude was 'all so unfair, so cruel'. And later:

'We are to have our wings clipped because we had imagination enough to see what could be made of Gregynog long ago, the vision of a New Jerusalem rising from the wreck of things.'

The sisters were acutely aware of hardship in the coalfield and of what Gwendoline called: 'The enemy Despair.' In south Wales in 1932 150,000 men were out of work. In the Rhondda and its neighbouring valleys more than half the men had no job. Meagre payments of the dole led to malnutrition, particularly among women. In the programme for the Gregynog festival in 1933 Gwendoline wrote: 'Thousands of our fellow human beings are dragging out a dark and desolate existence; exhausted and in despair they stand at the corners of the streets. A bewildered government doles out the pittance which keeps them alive, but their minds and spirits are starved. Their powers and potentialities are the same as ours, the same unseen beauty is theirs, could we but show it to them.'

David Davies built a summer camp in the Vale of Glamorgan for Rhondda boys. Margaret established charities for women and girls, a project dear to her heart. As a pioneer of girls' clubs she made the point that they needed help just as much as men and boys. She bought land at Boverton on the Glamorgan coast and set up a camp providing summer holidays for 600 girls from mining districts. They lived under canvas; and Margaret herself stayed in a tent during her visits. One evening she delighted everyone by joining in the Lambeth Walk, a popular dance. She also established a rest home at Boverton to provide holidays for the wives of miners employed in the Davies collieries. The emphasis was on food, fresh air and relaxation. 'Women who come on a Friday, pale, strained and under-nourished, pick up amazingly after a few days,' said a superintendent's report. 'They return home looking decidedly better. Many say they have renewed heart to face their difficulties after a complete break from the worries of unemployment and family troubles. It is amazing to watch mothers giving themselves up to enjoyment and relaxing like joyous children, an invaluable service to women whose only outlook is despairing.' Gwendoline told Tom Jones in a letter that Margaret was 'doing her bit for the Girls' Clubs – she is worth the whole bunch of us for doing her duty'.

In 1930 Margaret started Tŷ Gwyn, a home on the Merionethshire coast for skinny and underweight girls aged five to fourteen, particularly from south Wales. She funded a similar haven for women at Folkestone. A Rhondda miner's daughter who stayed at Ty Gwyn for more than a year, recalled that Margaret visited often and at Christmas took a gift for each girl. 'The children felt completely at home with her. She never came across as rich and haughty. She possessed an inner beauty.'

∞

In 1930 Tom Jones reached sixty, the civil service retirement age. Stanley Baldwin was out of office at that time and as he and TJ sat down for breakfast in London he said: 'Good news. A rich American called Harkness has given me two million pounds to spend for the benefit of this country.' Without missing a beat TJ said: 'Let me help you spend it.' Within days he was secretary of the Pilgrim Trust, set up to manage the Edward Harkness foundation in Britain. Its function was to promote the arts. TJ held the post for fifteen years and was later chairman.

'My very dear,' Gwendoline wrote to him after an education conference at Gregynog in November 1931, 'we are slowly recovering from our weekend. I think the outstanding feeling one has is disillusionment – I don't know what I expected a Director of Education to be like, but it all sounded so promising – the leaders, those who are laying the foundations of time to come. They came – and we have never had such a crowd of unimaginative, hide-bound, parochial-minded toughs inside this house before. This is a very improper letter – sorry – I feel like a cat that has had its fur stroked the wrong way and wish you were here to smooth it back again! Wow.'

She urged him to let her pay for a rest cure in France. 'I do wish you could get away to the sun,' she wrote in March 1932. 'It is not expensive – besides, expenses can always be overcome. Do think on these things.' At last, in May, he went to a health spa in Grasse. He wrote a letter to her and she complained of its 'tinge of self-righteousness', adding 'I could

scarcely believe it came from you – I was frightened lest the sun had somehow changed your mentality – I put it in the fire – why are you men so opinionated?'

She then took up the cause of his teeth. 'If you neglect them they will probably tumble out of their own accord so you might as well be sensible and consult Dr Field. You need not worry about the expense as I have already told you. Do be sensible. This is the last time of asking.' It was not, of course, and she wrote again. 'Do go to the dentist as soon as possible. He won't hurt you and it will save your teeth.' The campaign continued. 'I feel awfully worried about your teeth, it is most dangerous to neglect trouble. I am as you know only too glad to pay the piper since I am insisting on the tune. I am getting frightened – you are so obstinate.'

At last he submitted. 'Hope you are recovering after all your trouble at the dentist's hands,' Gwendoline wrote, 'I feel so responsible, but I am sure you will be glad.' A few days later she urged: 'I do want you to promise me you will take a real holiday and go to Aix-les-Bains, the baths seem to work such miracles. You want to sweat the poison out of your system. Do be a sensible fellow. You know you haven't to bother about expense. I can still manage that!'

'My very dear,' she wrote in February 1933. 'Thank you for your birthday wishes, for your letter and the book; thank you for – everything. It is such a joy to know that we can share so much together – the wonder of the hidden beauty of life, the stuff that dreams are made of, the holy bread, the food unpriced; to know that it is still there just as it was when I was a girl, acutely, deeply conscious of it all, before life rubbed the bloom off things. And you have brought it back again – the old power of communicating loveliness to others – I had it out in France – And now it has returned once more because you believe in me – you understand – you care. For I would be a light that shines which does not flicker nor grow dim, that you may see the beauty of the shadows. And I would be a song in your heart when days are weary; and I would be strong wings beneath you bearing you above all that is sordid, or petty or mean, that you may see the land that is very far off.'

doing secretarial work for me has been the cause. Miss Blaker was always dropping guarded hints that Dora talked too much.'

'My dear,' Gwendoline informed TJ in June 1933, 'Dora's got "swelled head" rather badly – transport trouble again. She will make arrangements with the chauffeurs behind our backs and when we give conflicting orders she blows me up!'

At the beginning of 1934 she wrote to him: 'You must hate women. I should if I were a man – always changing – mostly little petty spiteful things with small minds – Dora is vital to me in many ways as our minds work well together. Neither Daisy nor Miss Blaker has any conception of the nervous energy, the electric current, that has to run through things to make Gregynog alive. "Oh but you do enjoy it", is all I get from them! Daisy is a brick and does splendid work, but a brick is inclined to be unbending and rigid. Oh you understand alright, to keep the Press going at all Dora is vital. I am very fond of Dora, but I can't stand her uppishness.' The fact was, however, that Dora's warm and engaging personality, her music and singing skills and love of literature, were an asset, part of the spirit of Gregynog.

Three days later Gwendoline wrote to TJ: 'My dear – my very dear, Dora and I travelled down together yesterday and she was quite different – just the old Dora again. How can I ever replace her?' And then, in anguish: 'Oh my dear, Damn, Damn, Damn – Sorry! But that's just how I feel – Dora and I have been together again talking, talking. I won't give up the Press if I can help it – I can't help feeling we are trying to build up Jerusalem and throwing away our most useful tool – O damn again! Only I can't give in to Dora.'

In the spring of 1934 Gwendoline escaped these vexations, boarding a ship in the south of France for a cruise to Italy and Greece with her old school friend Bertha Herring and her nineteen-year-old nephew Michael, down from Cambridge. Michael described in his journal how the ladies were so engrossed in talking that they lost their place in a queue and missed an excursion ashore. After visiting Sicily, Athens, Crete and elsewhere they called at Naples. Gwendoline and Bertha had already explored the

excavations at Pompeii and Michael went to see them with a friend. In June he attended the Gregynog festival – 'everyone pleasant and charming except an American who had secured an invitation by doubtful means, and a soloist inclined to be grand'. He enjoyed Vaughan Williams's Mass in G Minor and saw Walford Davies given a presentation on becoming Master of the King's Musick. Michael fished the local streams and his grandmother gave him a car of his own. He went to Berlin with his father and remarked that their hotel had a view of Hitler's house. They travelled in Switzerland and Michael returned in time to see the Oxford and Cambridge cricket match at Lord's: it was a young man's idyllic summer in the 1930s.

In the following summer, William Burdon Evans sent Tom Jones a word snapshot of life at the Gregynog Press: 'Frankly, I am a little bit afraid of artists and other temperamental people. They so often run away with other people's wives or play shove-penny with the boys in their employ or talk sentimental tosh instead of getting on with the job. Sorry, but I am so painfully normal.'

Tom Jones's wife Eirene died in July 1935. 'She was the stabilizing factor,' he wrote of her, 'rudder, compass, lighthouse and everything that kept my more impetuous nature from shipwreck.' Eirene had always taken a generous view of TJ's platonic friendships with women. He himself wrote that 'the supreme blessing is the love of a good woman; the next best is the friendship of half a dozen'.

In November Gwendoline said: 'I am desperately sorry I wrote to you last night – you see it is the old habit of just telling TJ everything. You have been my refuge and strong tower for so long. Don't let anything come between us. Please excuse blots and smears G.' A little later she said: 'Been

thinking lots about you, dear, do be careful – you are very precious.' And, at Christmas: 'Dear Heart, I know how sad and full of longing these present days must be for you. I can only keep praying for you.'

In December the University of Wales proposed the award of honorary doctorates to Gwendoline and Margaret. 'We both feel it an honour we have done nothing to deserve,' they replied, 'and should be grateful if you would withdraw our names.' Asked by the university if he could change their minds Tom Jones said that their refusal was 'characteristic of their charming modesty'. He knew how resolute they were: he was reminded in 1935 of their unwavering sabbatarianism when Gwendoline refused his invitation to see a performance at the Arts Theatre. 'I should not go on a Sunday in any case,' she wrote tartly, 'and I am surprised you should have requested it – we have not quite come to that yet.'

# Threshold of war

Although he retired from the civil service in 1930 Tom Jones remained a frequent visitor to Downing Street and a confidant of Stanley Baldwin. In July 1936 he and some of the Downing Street staff grew concerned about Baldwin's health. The prime minister was sixty-nine and exhausted by anxiety about Germany and the constitutional crisis provoked by Edward VIII's romance with his American mistress. Tom Jones knew just the place for a worn-down leader. He conspired with Lord Dawson, the royal physician, who examined Baldwin at Chequers and prescribed a holiday. TJ swiftly arranged for the prime minister and his wife to go to Gregynog, and met them when they arrived on 7 August. Gwendoline herself eased the teetotal rule and wrote a letter she never dreamed she would write. 'Let me know about drinks,' she said to Tom Jones. 'Please send an order to Harrods for whatever they want, wines, beer, whisky, and it can be booked on account. There is nothing here as far as I know except a little brandy for emergencies!'

Harrods sent wines and spirits on a sale or return basis. Gwendoline and Margaret went to stay with their stepmother. The Baldwins surrendered to the care of Dora Herbert Jones and of Anderson, the butler.

'Here I am at that window you know so well,' the prime minister wrote to TJ, 'with the wonderful Dora next door, anticipating my every wish. What a country! What peace! And what healing air! I am soaking in

governments were not listening to his warnings. He was a Cassandra, burning himself out. He became tedious and people avoided him.'

Meanwhile the Temple of Peace and Health rose in Cathays Park in Cardiff as the embodiment of David Davies's faith in the peace movement and the ideals that had inspired the tuberculosis campaign in Wales. He gave £60,000 to finance its construction and his sisters paid for the furnishings. It was officially opened in November 1938 and dedicated to the memory of the men who lost their lives in 1914-18. Mrs Minnie James, of Dowlais, whose three sons were killed in the war, performed the opening ceremony.

A new quartet performing at the Gregynog festival in 1938 included Eldrydd Dugdale, a talented cellist. Her sisters Diana and Barbara were also gifted musicians. Lord Davies's heir, Michael, wrote three cello sonatas for Eldrydd. A romance bloomed between them and they married on 21 December 1939. The deepening shadow of war had ended any hope of a Gregynog festival that summer.

The Gregynog Press continued on its uncertain way. In 1936 Burdon Evans had ended Dora Herbert Jones's secretarial role at the press after ten years of service. Although deeply hurt she remained as secretary to Gwendoline and Margaret. James Wardrop, a Scot on the staff of the Victoria and Albert museum, became the part-time controller, the fourth and last. At the end of 1937 he produced the dramatic and sumptuous History of Saint Louis, one of the best of Gregynog's productions.

The press's fortieth book, published in 1939, was written by George Bernard Shaw and titled Shaw Gives Himself Away. In an echo of the Omar Khayyam beard affair Shaw wrote to Gwendoline about John Farleigh's frontispiece portrait, saying it made his beard look black, rather

than red. He sent an old photograph of himself. 'This is what I really looked like in 1895 except that the beard is too dark. Farleigh's drawing, tremendously stylized and heroic for Gregynog Press purposes, is just the thing for the book. I made him change the beard into a blonde one. He has left my blue-gray eyes too black: they belong to the black beard of the first version. You will get used to the portrait presently. It is a masterly drawing. Think how miserable the mere truth of the photograph would look beside it!'

Burdon Evans wrote to TJ at the end of 1939: 'The output of the Press for the past year has been deplorable, and the whole of the blame cannot be attributed to the world's prize egoist (GBS).' Indeed, he blamed Wardrop who had to go. TJ wrote ruefully to Gwendoline: 'I regret that

The smile of welcome: Gwendoline opens the Llandinam garden party in June 1939          *(National Library Wales)*

so rarely are we able to part with any Press employee in a quite unclouded atmosphere.' He made it clear that the press could not go on without a controller and Gwendoline replied in anguish. 'I was bitterly disappointed that you should envisage the closing of the press – surely at a time like the present we should try desperately to keep the things that matter alive – the things of beauty, treasures of the mind and the joy of creating. It won't be possible to open the press again once we close down. Forgive me, but oh, don't give up our dreams like this – without a struggle.'

The Soviet attack on Finland in November 1939 aroused the dragon in David Davies. Seeing the way the determined Finns drove back the initial Russian invasion he at once launched a committee of support and envisioned a British volunteer force going to help the resistance. The Conservative MP Harold Macmillan agreed to join him on an extraordinary fact-finding mission to Finland. Both of them veterans of the western front in the great war, they made a courageous and gallant duo. In the bitter weather of 10 February 1940 they flew to Malmo in Sweden and took a train to Stockholm. Lord Davies left his false teeth on the train and was distraught; but the Swedes found and restored them to him. He and Macmillan boarded a small aircraft which battled through a snowstorm to Helsinki. They spent two weeks meeting politicians and soldiers and touring the Finnish defences. Returning to London with their report, David Davies was all for sending a British brigade to reinforce the brave Finns. Little was done. To his profound dismay Finland surrendered to overwhelming Soviet force early in March.

# Art, love and money

War and winter forged gloomy alliance at Gregynog. Early in 1940 Gwendoline told Tom Jones of the 'awful havoc' wrought by storms, 'even nature joining in the destruction of so much of our work and dreams'. Many of the staff had left to join the forces. The sisters offered their home to the Red Cross and it served as a hospital and recovery home for more than 500 wounded servicemen, with Gwendoline appointed director. The Gregynog Press published poems by Lascelles Abercrombie, the forty-second and final book of the Davies era. The sisters sent their fine books, manuscripts and pictures to a rock chamber beneath the national library in Aberystwyth. Many British art treasures were removed from London to another bombproof refuge, a mountain cavern at Blaenau Ffestiniog in north Wales. The National Gallery offered to collect a Cézanne from Gregynog and store it in the cavern. The sisters, however, wrapped it in brown paper and gave it to their estate manager, Thomas Hughes. He drove to Bala and spent the night with the Cézanne under his hotel bed, delivering it next day. After the war the National Gallery insisted that experts should return the Cézanne to Gregynog, but Gwendoline and Margaret sent Hughes to retrieve it, brown paper and all.

The Greygnog choir gave a last recital at which Walford Davies played piano pieces. He died three months later in 1941, aged seventy-one, his life celebrated at a service in the music room he had filled with song and

she wrote: 'Dear TJ, looking forward to seeing you again soon. Yours ever GED.' After forty-one years this was the last of the hundreds of letters with which she had cemented their friendship. Margaret was with her when she left Gregynog on 24 June for treatment at the Radcliffe Infirmary in Oxford. Gwendoline died of leukaemia there on 3 July, aged sixty-nine, and was cremated the following day. Dora Herbert Jones arranged a service at Gregynog the day after that. One of the prayers gave thanks for Gwendoline's nurture of the arts and her love of the beautiful. Tom Jones wrote to Dora. 'No two persons in that congregation of friends had been nearer to her heart and mind than you and me in her most creative period,' he said. 'She was far from flawless, so are we, and I most certainly; but she had a burden of heredity and environment which you and I have been spared.' He composed an obituary note for The Observer. It was published under the headline: The Delightful Hostess. Gwendoline left him an annuity of £200. 'I hardly thought she would have the courage to do this publicly,' he wrote, 'she was so shy and timid.' Tom Jones himself died in October 1955, aged eighty-five. As he had always hoped, he left less than £5,000. 'An old friend and colleague,' said a tribute written in the Gregynog visitors' book, 'he helped to form the policies of this house and family.' Dora Herbert Jones died in 1974 aged eighty-three.

Gwendoline's estate amounted to £863,662. She bequeathed all the pictures and sculptures she collected from 1908 to 1926 to the National Museum of Wales. They arrived in Cardiff in October: seventy-eight oil paintings, twenty-six drawings and watercolours and five pieces of sculpture. The bequest included six Monets, two Manets, two Renoirs, three Cézannes, four Corots, five Millets, seven Daumiers, three Whistlers, seven Turners, three Gainsboroughs and a Constable.

At a stroke the bequest raised the national museum to an international standing. 'It made a sensational difference,' said the art historian Eric Newton. 'It changed the balance of power among British art galleries

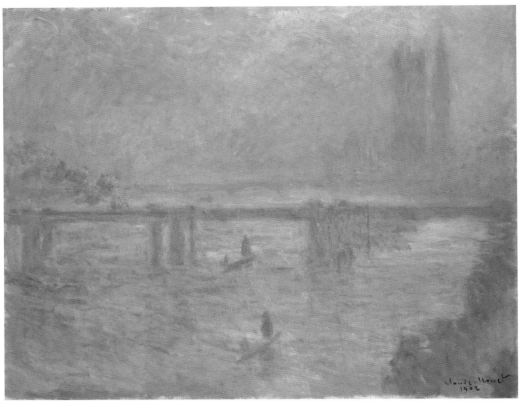

Monet                              *Charing Cross Bridge* 1902

In a grand creative burst Monet painted eighty-five
Thames views including thirty-five of Charing Cross
Bridge and forty-two of Waterloo Bridge

Renoir                              *Young Girl in Blue* 1880s

Renoir's income in the 1880s was growing through his success with
portraits and a more traditional way of painting

and turned an imperfect collection into a place of pilgrimage.' Writing in The Connoisseur in March 1952, John Steegman, keeper of art at the national museum, said 'the crowning benefaction of Gwendoline Davies to her native country' transformed the art department. 'The inspired guidance of Hugh Blaker, and Gwendoline's courage in following it, enabled her to acquire first-rate examples of Daumier, Monet, Renoir, Manet, Degas, Cézanne, van Gogh ... at a time when these masters were by no means widely appreciated.' The Times described 'a rich collection of works that were for the most part acquired under the advice of Hugh Blaker, well in advance of the general taste in this country. It took great courage, though it may not be easy to realize this at the present time, to buy even the most enchanting Renoir (in 1913) and perhaps still more to buy (two) Cézannes in 1918. Miss Davies had not only an adventurous but a catholic taste'. Dr Dilwyn John, director of the national museum, said Gwendoline's bequest was 'far and away the most important the museum has received'.

After Gwendoline bought her last picture in 1926 there was no collecting until Margaret resumed buying on a more modest scale in 1934. She did not pay the high prices of the collecting heyday. She bought *Mornington Crescent* by Harold Gilman, a painter of townscapes and a founder of the Camden Town Group, and in 1935 paid £125 for Walter Sickert's *Palazzo Eleanora Duse, Venice*. In contrast with many dreamy Venetian scenes this one, painted in 1904, shows the buildings as rather down at heel. In 1937 Margaret acquired *Dahlias and Canterbury Bells* by Vanessa Bell and *Dorelia McNeil as an Irish girl* by Augustus John. She also became the owner of Millet's oil *The Gust of Wind,* a picture bursting with drama and power, depicting the moment when a tree is torn from the earth in a storm and a shepherd runs headlong for his life. Hugh Blaker purchased the painting in 1924. Margaret received it from his sister Jane, the only beneficiary of his estate. In 1938 she bought *A Street in Nantes*, an oil by Christopher

Wood, a St Ives artist who painted vividly in Cornwall and Brittany. In 1939 she purchased seven watercolours by Moses Griffith, including his view of Gregynog. After the war she resumed buying in 1948. Following Gwendoline's death she augmented her collection in the clear knowledge that it would form her own bequest. Mostly she bought contemporary British works and combined her personal taste with an objective eye to relevance. She had the advice of John Steegman. During the late 1940s and in the 1950s she travelled to France, Belgium, Spain, Austria, the Netherlands, Switzerland, Norway and Germany. In 1949 she accepted an honorary doctorate of laws from the University of Wales.

Millet    *The Gust of Wind* 1870s

Cataclysmic drama: the oak takes violent flight and the shepherd flees in terror

| Brangwyn | *Interior of the Duomo, Taormina* | £12.12s |
| Clausen, George | *The Door of the Parthenon* | £12.12s |
| Daumier, Honoré | *The Night Walkers* | £338.16s |
| Millet | *The Shooting Stars* | £1,080 |
| Millet | *Winter, the Faggot-Gatherers* | £1,608 |
| Millet | *Seated Shepherdess* | |

**1913**

| Legros, Alphonse, | *Portrait A. Rodin* | £4.4s |
| DerzkenVan Angeren, Antoon | *At the Landing Stage* | £1.1s |
| Lemon, Arthur | *Boy Seated on Grass* | £10.10s |
| Lemon | *Setting Dry* | £21 |
| Whistler | *Street at Saverne* | £10.10s |
| Mancini, Antonio | *Portrait of a Girl* | £400 |
| Renoir, Pierre-Auguste | *La Parisienne* | £5,000 |
| Rodin | *Saint John, Preaching* | £2,000 |
| Monet | *Charing Cross Bridge* | £1,600 |
| Rodin | *The Clouds* | £3,045 |
| Carrière, Eugène | *Maternity (Suffering)* | £950 |
| Carrière | *The Footbath* | £350 |
| Monet | *Le Palais Dario* | £1,310 |
| Monet | {*Nympheas, 1905)* | |
| | {*Nympheas, 1906)* | |
| | {*Nympheas, 1908)* | £3,370 total |
| Monticelli, Adolphe | *Summer Court* | £580 |
| Daumier | *Workmen on the Street* | £1,800 |
| Maris, Mathius | *In the Woods At Evening* | |
| Maris | *Joyous Walk* | |
| Turner | *Fort de L'Esseillon Val de la Maurienne* | £130 |
| Maris | *He is Coming* | £5,250 |
| Whistler | *The Little Lagoon* | £105 |
| Whistler | *The Traghetto* | £185 |
| Whistler | *The Mast* | £73.10s |
| Mancini, Antonio | *Portrait of a Girl* | |

**1914**

| Daumier | *Head of a Man* | £560 |
| Mancini | *The Fortune Teller* | £200 |
| Daumier | *The Heavy Burden* | £600 |
| Renoir | *Young Girl in Blue* | £600 |

| | | |
|---|---|---|
| Carrière | *Maternity* | |
| Carrière | *Mother and Child* | |
| Daumier | *The Watering Place* | £2,000 |
| Rodin | *The Earth and the Moon* | £2,800 |
| Pryde, James | *Rag Alley* | £250 |
| Mastenbroek | *Amsterdam* | £27 |

**1916**

| | | |
|---|---|---|
| John, Augustus | *(Study of two women bathing)* | |
| John | *(Head of Dorelia McNeil)* | |
| John | *(Study of two nudes)* | |
| John | *(Romany Folk)* | £600 total |
| John | *Old Ryan* | £250 |
| John | *(Self Portrait)* | |
| John | *(Bathers)* | |
| John | *(Pyramus John)* | |
| John | *(Pyramus John)* | |
| John | *(Dorelia McNeil in a Feathered Hat)* | |
| John | *(Study of an Old Man's Head)* | £1,500 total |
| Rodin | *Eve* | £1,500 |
| Seguin, Armand | *Breton Peasant Women at Mass* | £750 |
| Whistler | *Snowstorm: Nocturne*, manner of | |

**1917**

| | | |
|---|---|---|
| Carrière | *The Tin Mug* | £1,650 |
| Daumier | *Lunch in the Country* | £1,290 |
| Renoir | *Conversation* | £2,000 |
| Manet | *The Rabbit* | £1,000 |
| Monet | *Rouen Cathedral: Setting Sun* | £1,350 |
| Rodin | *Bronze Head of Victor Hugo* | |
| Rodin | *Bronze Head of Mahler* | £1,050 |

**1918**

| | | |
|---|---|---|
| Maris | *Castle Ploughman* | £450 |
| Stevens, Alfred | *Seated Girl* | £250 |
| Cézanne, Paul | *The François Zola Dam* | £2,500 |
| Cézanne | *Provençal Landscape* | £1,250 |
| Daumier | *Don Quixote Reading* | £811 |
| John | *Edwin John* | £140 |
| Whistler | *Seamstress*, style of | £3,000 |

## 1919

| | | |
|---|---|---|
| Constable | *The Weir*, manner of | £1,500 |
| Eeckhout, Gerbrandt van den | *Adoration of the Shepherds* | £200 |
| Raeburn | *Mrs Tod of Drygrange* | £3,250 |
| Turner | *Rhine Gate Cologne* | £350 |
| Turner | *The Rainbow* | £800 |
| Turner | *Wurzburg* | £1,520 |
| Vlaminck, Maurice de | *Village Street* | £104 |
| Vlaminck | *The Bridge* | |
| John | *W H Davies* | £550 |
| Daumier | *A Third Class Carriage* | £900 |
| John | *The Little Family* | £3.3s |
| John | *The Little Pilgrims* | £4.4s |
| John | *The Quarry Folk* | £4.4s |
| John | *Virginia* | £4.4s |
| John | *The Big Grotto* | £3.3s |
| John | *The Little Shepherdess* | £3.3s |
| John | *Nude Seated* | £3.3s |
| John | *Les Femmes* | £3.3s |
| John | *Damnées* | £3.3s |
| John | *The Fruit Sellers* | £3.3s |
| John | *Maenad Resting* | £3.3s |
| Lawrence, Thomas | *Children of the Duke of Hamilton* | £580 |

## 1920

| | | |
|---|---|---|
| Cuyp, Benjamin Gerritsz | *Parable of the Blind* | £450 |
| Botticelli, Sandro | *Virgin and child with a Pomegranate,* workshop of | £5,000 |
| Signac, Paul | *St Tropez* | £15.5s |
| Cézanne | *Still Life with Teapot* | £2,000 |
| Cézanne | *The Diver* | £165 |
| Cézanne | *Bathers* | £165 |
| Carrière | *Aurora* | £210 |
| Chavannes, Puvis de | *Legende de Ste Genevieve,* study for | £312 |
| Daumier | *The Lawyer and his Client* | £450 |
| Derain, André | *Mme Zborowska* | £150 |
| Vlaminck | *Landscape* | |
| Manet | *Argenteuil, Boat (Study)* | £1,400 |

| | | |
|---|---|---|
| Gogh, Vincent, van | *Rain- Auvers* | £2,020 |
| Velazquez, Diego | *Boy with a Flagon*, manner of | £800 |
| Pissarro, Camille | *Port de Rouen* | £550 |
| Pissarro | *Pont Neuf, Snow Effect* | £220 |
| Pissarro | *Peasant Girl* | |
| Pissarro | *Two Peasant Girls* | |
| El Greco, Domenico | *St John the Baptist*, studio of | £800 |
| Burne-Jones, Sir Edward | *Wheel of Fortune* | £550 |
| Hals, Frans, | | |
| now 17th century Dutch | *Portrait of a Lady* | £9,000 |
| van Dyck, Sir Anthony | *Abraham van Diepenbeck* | £800 |

**1921**

| | | |
|---|---|---|
| Lewis, Wyndham | *Ezra Pound* | £32.11s |
| Daumier | *L'Avocat* | |

**1922**

| | | |
|---|---|---|
| Barker, Thomas | *Cattle Fair* | £42 |
| Turner | *The Beacon Light* | £2,625 |
| Botticelli | *Virgin adoring the Child with the young St John*, workshop of | £525 |
| Gainsborough, Thomas, after | *(Peasants and Donkeys)* | |
| Gainsborough | *(Rocky Landscape)* | £1,550 total |
| El Greco | *St Peter*, follower of | £550 |
| Daumier | *(Head of a Man)* | |
| | *(Two Studies for the Return of the Prodigal Son)* | £220 total |

**1923**

| | | |
|---|---|---|
| Degas, Edgar | *Dressed Dancer, Study* | £450 |
| Degas | *Dancer looking at the Sole of her Right Foot* | £350 |
| Rich, Alfred | *Richmond, Yorkshire* | |
| Rich | *Corn Stooks* | |
| Rich | *Corfe* | |
| Rich | *Study of Three Trees* | |
| Rich | *River at Ludlow* | |
| El Greco | *The Disrobing of Christ* | £6,000 |

**1924**

| | | |
|---|---|---|
| Boudin | (*Village Market*) | |
| Boudin | (*Beach at Trouville*) | £95 total |
| Boudin | *Riverside Scene* | £7.7s |
| Lawrence, Sir Thomas | *A Child* | £440 |

**1925**

| | | |
|---|---|---|
| Sargent, John Singer | *Hercules Brabazon Brabazon* | £399 |

**1926**

| | | |
|---|---|---|
| Wilson, Richard | *View in Windsor Great Park* | £460 |

**1927**

| | | |
|---|---|---|
| Gainsborough, after | *Landscape with Cattle and Figures* | £315 |

**Acquired between 1908 and 1927, date of purchase unknown**

| | |
|---|---|
| Barker, Thomas | *Self Portrait* |
| Blake, William | *Christ trampling down Satan* |
| Barbazon Brabazon, Hercules | *Lucerne* |
| Emile Fabry | *War* |
| Gainsborough, after | *Landscape with Figures* |
| Lawrence | *A Girl* |
| Morisot, Berthe | *Woman and Child in a Meadow at Bougival* |
| Paulus, Pierre | *The Flight* |
| Turner | *The Leyen Burg at Gondolf on the Mosel* |
| Wilson, Richard | *A White Monk*, perhaps by |

**1934**

| | | |
|---|---|---|
| Gilman, Harold | *Mornington Crescent* | £95 |

**1935**

| | | |
|---|---|---|
| Edzard, Dietz | *Two Friends* | £60 |
| Sickert, Walter | *Palazzo Eleanora Duse, Venice* | £125 |
| Dunlop, Ronald Ossary | *Flowers* | £26.5s |

**1937**

| | | |
|---|---|---|
| Bell, Vanessa | *Dahlias and Canterbury Bells* | £26.5s |
| John | *Dorelia McNeil as an Irish girl* | £50.8s |
| Millet | *The Gust of Wind* | |

**1938**

| | | |
|---|---|---|
| Wood, Christopher | *A Street in Nantes* | £25 |
| Lewis, Edward Morland | *Street in Spring* | £10.1s |
| Gwynne-Jones, Allan | *Flowerpiece* | £25 |

**1939**

| | | |
|---|---|---|
| Griffith, Moses | *Llan St Fraid* | |
| Griffith | *Nannerch Church* | |
| Griffith | *St Winifred's Well, Holywell* | |
| Griffith | *Gregynog House* | |
| Griffith | *Capel Currig* | |
| Griffith | *Llanelltyd Bridge, Merionethshire* | |
| Griffith | *Bala Pool, Llyntagit* | £138 total |

**1948**

| | | |
|---|---|---|
| Friesz, Othon | *La Ciotat* | £36.15s |
| John | *Donegal Shawls* | £78.15s |
| Lehmann, Leon | *House at Beaufort* | £36.15s |
| Meninsky, Bernard | *Baby in arms* | £7.35s |
| Gosse, Sylvia | *The Seamstress* | £26.5s |
| Maitland, Paul | *Boats on the Thames at Chelsea* | £31.1s |

**1950**

| | | |
|---|---|---|
| Hitchens, Ivon | *Trees from a House Roof: Autumn* | £120.5s |

**1951**

| | | |
|---|---|---|
| Spear, Ruskin | *Approach to Hammersmith Bridge* | £94.10s |
| Le Bas, Edward | *Dustcart la Ciotat* | £63 |

**1952**

| | | |
|---|---|---|
| Innes, James Dickson | *Collioure* | £31.10s |
| Innes | *Cathedral at Eine* | £262.1s |
| Williams, Kyffin | *Moel Hebog* | £18.18s |
| Williams | *The Moelwyns from Aberglaslyn* | £33.12s |
| Morris, Cedric | *Near Cagnes* | £78.15s |
| Walker, Ethel | *Rough Sea, Yorkshire* | £47.5s |
| Lees, Derwent | *Lyndra at Aldbourne* | £47.5s |
| Devas, Anthony | *Bathers* | £40 |

# The value of money

Attempts to determine modern equivalents to the prices of a century ago can be misleading. Internet yardsticks suggest that £1 in 1914 is equivalent today to about £100. But considering inflation, and the startling prices of art today such conversions have little meaning in the price of pictures.

The first picture in the Davies collection in 1906 cost £10.10s. That would have covered a year's wages for a maid. A top cook-housekeeper cost £80 a year. A room in London hotel was seven shillings. An eight-bedroom country house with stables cost £2,300. A four-figure income was a middle-class ambition, but more often a dream.

# The Davieses of Llandinam

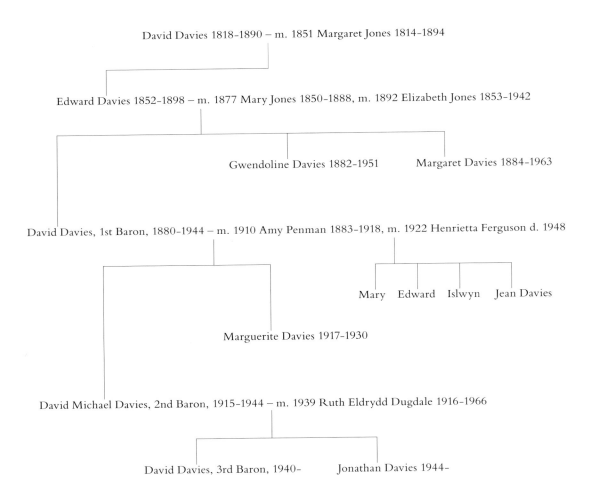

David Davies 1818-1890 – m. 1851 Margaret Jones 1814-1894

Edward Davies 1852-1898 – m. 1877 Mary Jones 1850-1888, m. 1892 Elizabeth Jones 1853-1942

Gwendoline Davies 1882-1951          Margaret Davies 1884-1963

David Davies, 1st Baron, 1880-1944 – m. 1910 Amy Penman 1883-1918, m. 1922 Henrietta Ferguson d. 1948

Mary   Edward   Islwyn   Jean Davies

Marguerite Davies 1917-1930

David Michael Davies, 2nd Baron, 1915-1944 – m. 1939 Ruth Eldrydd Dugdale 1916-1966

David Davies, 3rd Baron, 1940-          Jonathan Davies 1944-

# Acknowledgements and sources

The Gwendoline and Margaret Davies Charity commissioned this book. As the writer I was the nib at the end of a long pen. Lord and Lady Davies of Llandinam were from the outset enthusiastic, thoughtful and hospitable.

Among many who shared their knowledge of the family, the art and philanthropy, were Dr Glyn Tegai Hughes and Denis Balsom, former wardens of Gregynog; Dorothy Harrop, historian of the Gregynog Press; the writer Carolyn Stewart; Professor Robert Meyrick, head of school and keeper of art at Aberystwyth University; Oliver Fairclough, keeper of art at the National Museum of Wales, Bethany McIntyre, the museum's assistant curator of prints and drawings; and Dr Ann Sumner, formerly head of fine art at the museum. David Lewis lent me his own researches into the Davies story and the Gregynog Press. Amanda Saunders gave me a copy of her absorbing BA dissertation *The Davies Sisters, The Nonconformist Philanthropists of Gregynog*. Susan Morgan gave me her family's written recollections. Janet Lewis and Camilla Davies drew on their knowledge of the family and the story of the sisters. Three of the first Lord Davies's children, Islwyn, Mary and Jean, had talked to me during the making of a television programme on the Davies family in 1998. More recently I had the kind help of Shara Leonard and Lady (Shirley) Hooson.

At Gregynog, Karen Armstrong, the director, and Mary Oldham, archivist, were always supportive. David Vickers, former controller of the Gregynog Press, told me its story. David Steeds, of Aberystwyth university, talked to me of the career of the first Lord Davies; Hugo

Herbert Jones of his mother Dora Herbert Jones; Dafydd Rowland Hughes of the pacifist George M Ll Davies; Professor David Jenkins of the sisters' skill in choosing gifts for children and staff. His mother worked at Gregynog. Peter Walters, Thelma Watkin and Clive Edwards also shared their recollections of life at Gregynog Hall and the Press.

For David Davies, founder of the family fortune, I referred, among other sources, to Herbert Williams's authoritative *Davies the Ocean: Railway King and Tycoon* (University of Wales Press 1991); and Ivor Thomas's *Top Sawyer: a biography of David Davies of Llandinam* (Longmans 1938). For political and industrial background I consulted Kenneth O Morgan's *Wales in British Politics 1868–1922* (UWP 1963) and *Rebirth of a Nation 1880–1980* (UWP 1981); and John Davies's *History of Wales* (Penguin Press 2001).

Eirene White's *The Ladies of Gregynog* (UWP 1985) is valuable on the Davies sisters' background, as is Ian Parrott's *The Spiritual Pilgrims* (C Davies 1969). The sisters' story is part of *An Elusive Tradition* by Eric Rowan and Carolyn Stewart (Art and Society in Wales UWP 2002).

The indispensable works of the National Museum of Wales include *The Davies Collection of French Art*, by John Ingamells 1967; *Art in Exile: Flanders, Wales and the First World War*, edited by Oliver Fairclough 2002; *Things of Beauty: What Two Sisters Did for Wales*, ed Fairclough 2007; *A Companion Guide to the Welsh National Museum*, ed Fairclough 2011; *Sisters Select: Works on paper from the Davies Collection*, edited by Bethany McIntyre 2000; *Colour and Light: Fifty Impressionist and Post-Impressionist works at the National Museum of Wales*, ed by Ann Sumner 2005. *Turner to Cézanne: Masterpieces from the Davies Collection*, by Fairclough and Bryony Dawkes, was published by the American Federation of Arts 2009; and *Radical Vision: British Art 1910–1950*, by Dawkes and Robert Meyrick (Oriel Davies 2006). Peter Lord's *The Visual Culture of Wales: Industrial Society*; and *The Visual Culture of Wales: Imaging the Nation*, (UWP 1998, and 2000) and *Winifred Coombe Tennant: a Life through Art*, (National Library of Wales 2007), were invaluable. The sisters have their significant place in the excellent *Great Women Collectors*, by Charlotte Gere and Marina

Vaizey (Philip Wilson 1999). Belinda Thomson's *Impressionism: Origins, Practice, Reception* (Thames and Hudson 2011) is as fresh as it is detailed.

Articles referred to included Mark Evans's *The Davies Sisters of Llandinam and Impressionism for Wales* (Journal of the History of Collections 2004); Peter Cannon-Brookes's *The Davies Sisters of Gregynog* (Apollo 1979); Robert Meyrick's *Hugh Blaker: Doing his bit for the moderns* (Journal of the History of Collections, 2004); Matthew Denison's *Prim Pioneers* (Telegraph Magazine 2007); Bryony Dawkes's *A Tale of Two Sisters, the Davies Collection of French Art from The National Museum of Wales* (Antiques and Fine Art, 2009); *Hugh Oswald Blaker*, an MA dissertation by John Stather 1990.

Dr Edward Ellis's *TJ: A Life of Thomas Jones* (UWP 1992) is the commanding biography. His volume *The University College of Wales Aberystwyth 1872-1972* (UWP 2004) describes the Davies family's crucial part in the college's founding and funding. Thomas Jones's books *Rhymney Memories* (Welsh Outlook Press 1938), *Leeks and Daffodils* (Welsh Outlook 1942), Welsh Broth (W Griffiths 1950), *A Diary with Letters 1931–50* (OUP 1954) are naturally informative. The saga of Gregynog Hall, its history and development between the wars as a venue for art, conferences and music festivals, is told by Glyn Tegai Hughes, Prys Morgan and J Gareth Thomas in *Gregynog* (UWP 1977). Dorothy Harrop's *A History of the Gregynog Press* (Private Libraries Association 1980) is the key work. I also referred to Michael Hutchins's *Printing at Gregynog*, 1976. For the first Lord Davies I referred to essays by J Graham Jones, formerly head of the Welsh Political Archive at the National Library.

I consulted Michael Ellis Jones's account of his Montgomeryshire upbringing, *A Boyhood Recall 1937-1945*; David Ian Allsobrook's *Music for Wales* (UWP 1992); Jeremy Pryce's *Llandinam: A Glimpse of the Past*; Arthur Marwick's *Women at War 1914–1918* (Fontana/Imperial War Museum 1977); *Edwardian England*, ed by Simon Nowell-Smith ed (OUP 1964); *Who's There? The Life and Career of William Hartnell* by Jessica Carney (London 1996); *Mauve: How one man invented a colour that changed the world* (Faber 2000); Agnes M Dixon's The *Canteeners* (John Murray 1917).

Some of the sources are in the library of the National Museum of Wales, and the Museum of Welsh Life; and many are in the Llandinam and Davies papers, and the Thomas Jones papers, in the National Library. My thanks to the helpful staff at these institutions; and to Penny for her constancy.

# Index